Alwyn Crawshaw's

OIL PAINTING
COURSE

Alwyn Crawshaw's

OIL PAINTING
COURSE

Collins

First published in hardback in 1992 by
HarperCollins*Publishers*
77-85 Fulham Palace Road
Hammersmith
London W6 8JB

Reprinted 3 times
First paperback edition published in 1999 and reprinted 4 times

This edition first published in 2004 by
Collins, an imprint of
HarperCollins*Publishers*

The Collins website is www.**collins**.co.uk

Collins is a registered trademark of HarperCollins Publishers Limited

10 09 08 07 06 05 04
7 6 5 4 3 2 1

The catalogue record for this book is available from the British Library

Designed by Trevor Spooner
Edited by Joan Field
Photography by Nigel Cheffers-Head

ISBN 0 00 716677 X

Printed and bound by Printing Express Ltd, Hong Kong

ACKNOWLEDGEMENTS

It is because of the students who have taken part in our
painting courses over the years that I have been able to
write this book, and I should like to offer all of them
my grateful thanks. I am also indebted to Cathy
Gosling of Collins, Trevor Spooner for designing the
book, Joan Field for editing and Gertrude Young for
typing the manuscript; finally to my wife June, who
has helped and taught with me on all the courses we
have held.

The oil painting reproduced on page 128 is by June Crawshaw.

The paintings illustrated on pages 13 and 32 are reproduced by
kind permission of TSW-Television South West

CONTENTS

YOUR TUTOR

Fig. I Alwyn Crawshaw working outdoors

Successful painter, author and teacher, Alwyn Crawshaw was born at Mirfield, Yorkshire and studied at Hastings School of Art. He now lives in Norfolk with his wife June, who is also an artist.

Alwyn is a Fellow of the Royal Society of Arts, and a member of the British Watercolour Society and the Society of Equestrian Artists. He is also President of the National Acrylic Painters Association and is listed in the current edition of *Who's Who in Art*. As well as painting in watercolour, Alwyn also works in oil, acrylic and occasionally pastel. He chooses to paint landscapes, seascapes, buildings and anything else that inspires him. Heavy working horses and winter trees are frequently featured in his landscape paintings and may be considered the artist's trademark.

Alwyn has written eight books in the Collins *Learn to Paint* series. His other books for HarperCollins include: *The Artist At Work* (an autobiography of his painting career), *Sketching with Alwyn Crawshaw*, *The Half-Hour Painter*, *Alwyn Crawshaw's Oil Painting Course*, *Alwyn Crawshaw's Acrylic Painting Course* and *Alwyn & June Crawshaw's Outdoor Painting Course*.

To date Alwyn has made seven television series for Channel 4: *A Brush with Art*, *Crawshaw Paints on Holiday*, *Crawshaw Paints Oils*, *Crawshaw's Watercolour Studio*, *Crawshaw Paints Acrylics*, *Crawshaw's Sketching & Drawing Course* and *Crawshaw Paints Constable Country*, and for each of these he has written a book of the same title to accompany the television series.

Alwyn has been a guest on local and national radio programmes and has appeared on various television programmes. In addition, his television programmes have been shown worldwide, including in the USA and Japan. He has made many successful videos on painting and is also a regular contributor to the *Leisure Painter* magazine and the *Australian Artist* magazine. Alwyn and June organize their own successful and very popular painting courses and holidays. They also co-founded the Society of Amateur Artists, of which Alwyn is President.

Alwyn's paintings are sold in British and overseas galleries and can be found in private collections throughout the world. His work has been favourably reviewed by the critics. *The Telegraph Weekend Magazine* reported him to be 'a landscape painter of considerable expertise' and the *Artists and Illustrators* magazine described him as 'outspoken about the importance of maintaining traditional values in the teaching of art'.

THE COURSE

Fig. 2 A group of students on an overseas painting course watching me do a demonstration

This book is based on some of the painting courses which I have organized and conducted for many years. The lessons and exercises that follow have been structured to take you from the beginning, step by step, through many phases of oil painting. If you are a student who has ventured previously into oil painting, I suggest you start where you think your ability stops. On the other hand, because all artists are different and ideas and teaching methods vary, if you start with Lesson 1, you may learn something new that could advance your progress. Personally, I find that I learn a little more with every painting I do.

Students often attempt something too complicated and beyond their ability to begin with, then have a disaster on their hands; so I will lead you progressively through the lessons to build your confidence. However, this means that you will have to be patient and follow each lesson faithfully. And if your first success is only a simple painting of a box, or a lemon, it will carry you through to the next lesson, until you are painting masterpieces.

Naturally, during a painting course I 'hover' around the students to help motivate them and to help them individually with their problems, but you will have to discipline yourself as you work through these lessons without my being there. However, I am sure you will do as well – in fact, some of you may do better!

If you are trying oils for the first time but you have painted in another medium, I suggest you work from the beginning of this course. Don't assume that a particular technique or way of working is the same as in your present medium. It may or may not be, so do read everything.

On all my courses – whether they last one day or two weeks – my wife June, who is also an artist, helps me, and we work as a team. So when I refer to 'June' or 'we' in the text, you will know who June is.

A painting course always starts indoors so that you are in control of the physical elements: comfort, subject, light and warmth. This is very important, especially for the beginner. It is vital to feel confident that you know how to start a painting and to control the medium before you go outdoors to paint from nature for the first time.

Of course, when working from this book you can't ask questions, so it is essential to read it through from beginning to end before you start to paint.

My aim in writing this book (course) is to give you confidence to paint in oils, but especially to give you inspiration and the will to practise and succeed. I know that together we can bring out your artistic talents. Good luck!

Alwyn Crawshaw

THE EXCITEMENT OF OIL PAINTING

When I started to write this chapter I was collecting everything together for this book – ideas, sketches, subjects to paint – and deciding on the order of the lessons. I was surrounded by my sketches, paintings, photographic slides, notes, and all the necessary bits and pieces, including my favourite pen (now held together with Cellotape!), which I have used for all my painting books.

Because of all this preparation work I hadn't been out oil sketching for a few weeks, and one morning I just couldn't wait any longer. I had to make a trip into the town, which is by the sea, so I took my Oil Travelling Studio (see pages 18 and 19).

On the beach the wind was almost gale force and I was looking into the sun, which kept appearing from behind some dark, ominous clouds. The conditions were not good for painting because it was also very

cold. But I felt excited. I stood on the beach and painted away for about 20 minutes, producing the sketch in **fig. 3**. I think the sky is rather too pink and the horizon runs up-hill a little on the left of the painting. That happened simply because I could not keep the painting, or my hand, steady because of the strong wind! A few waves found their own position on the painting for the same reason. But it released a tremendous amount of creative tension within me. When I had finished, I stood and looked at my painting and knew I was taking away with me an experience. Every time I look at the sketch, my mind returns to that day, and through the painting I re-live those minutes of gale-force winds, the bright sunlight when the clouds broke, and the pounding waves on the beach. But above all, I was excited because I had created a picture – a picture which captured a time in

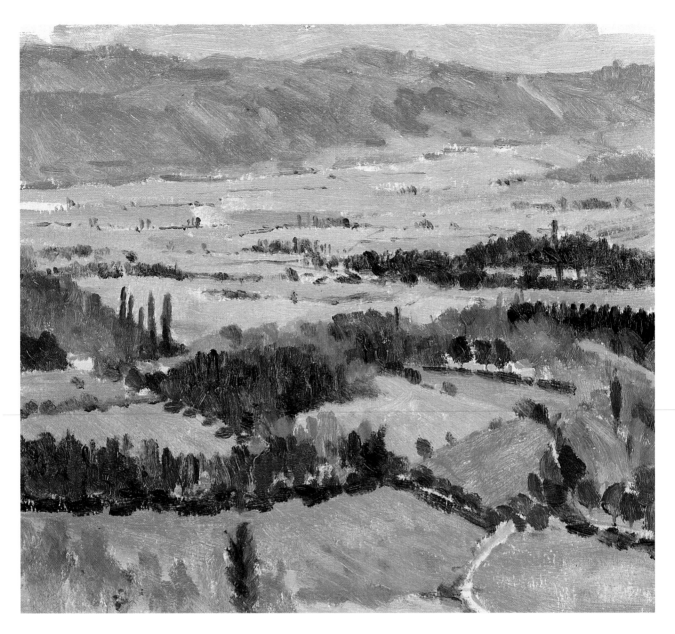

Fig. 3 (opposite) *From Dawlish beach*. Primed hardboard,
15 × 20 cm (6 × 8 in)

Fig. 4 (above) *From Forcalquier, Provence*. Primed Whatman
paper, 25 × 30 cm (10 × 12 in)

my life that would live forever. Back in my studio, I
felt I had to start the book with this sketch, because it is
such experiences that make painting so exciting as well
as so enjoyable.

Naturally, you don't have to be on a beach in a gale-
force wind to become excited about painting! You can
raise just as much enthusiasm sitting comfortably at the
edge of a cornfield, painting a sunlit meadow on a hot
day. In fact, I painted the scene in **fig. 4** on a lovely
hot day on the top of a steep hill in Provence, as a
demonstration for some students on one of my
courses. My wife June and I started the trek up the hill

with 18 students. When we arrived at the top we had
only 12, the others having decided that the view was
just as good half-way up the hill, and the climb not so
tiring! The vastness of the landscape before us when
we reached the top was breathtaking – it was worth
the climb. I keep this painting in my studio and every
time I look at it, the memories of that wonderful day
come flooding back to me. This can happen to all of
us, and we don't need a masterpiece to make it
happen. When you create a painting, whatever the
standard, however small or large, the fulfilment and
feeling of achievement it gives you make all the time
and effort worthwhile.

I find it very difficult, at times, to sell a painting
done on location, because of the memories it holds. Of
course, I do have to sell them – well, almost all of
them – because that's how I make my living; but take
it from me, the old saying that when an artist sells a
painting he sells part of himself, is absolutely true.

If I ever sell the painting in **fig. 5**, I shall certainly be losing some of my memories. June and I took a group of 18 students to Tuscany in Italy, and one day we went to a vineyard to paint. When we arrived we were given a tour of the vineyard, and afterwards a fabulous lunch with a selection of wines. Then, after lunch, the painting. It was a hot day, everybody was relaxed, and I did this demonstration painting looking over the vineyard. Incidentally, there were some good paintings done that day, in spite of the location!

When you look at life with an artistic eye, you see nature quite differently. If you are a beginner, you have much to look forward to as you work through this course. If you have already done some painting, you will understand when I say I can become just as excited about a dull, misty, rainy day as a lovely hot summer's day; or an old wall with crumbling plaster falling away, revealing warm-coloured red bricks and yellowing cement. Even the thought of that wall can start my artistic blood rushing through the veins of my painting hand!

Over the years, students have come back to me and said how much they now appreciate being out in the countryside; they enjoy it more than they had ever done before, as they see it from a painter's point of view. I paint many trees in winter, and students have often told me that they saw a 'Crawshaw tree' when they were out, or a 'Crawshaw muddy path'. As time goes on you will discover a subject that really inspires you – it may be water reflections, or cottages nestled in the countryside – and your friends will relate a particular scene to you. This is good, because you will have relaxed into your painting. Of course, it does not mean that you don't paint other subjects; as your painting develops so does your subject matter. After working on them, you will gradually eliminate subjects until, like most artists, you find your natural métier. It could be portraits, seascapes, still life,

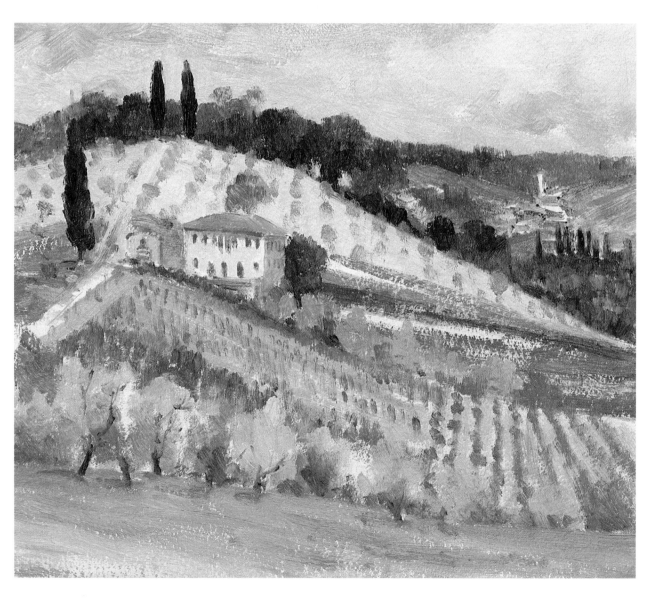

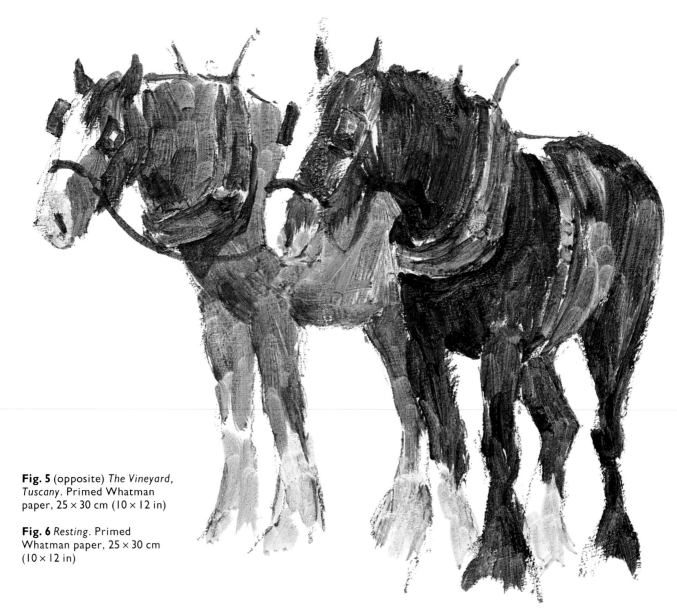

Fig. 5 (opposite) *The Vineyard, Tuscany*. Primed Whatman paper, 25 × 30 cm (10 × 12 in)

Fig. 6 *Resting*. Primed Whatman paper, 25 × 30 cm (10 × 12 in)

landscapes, equestrian subjects, town scenes, and so on, and even within those subjects there are specialized areas. For instance, with landscape you may prefer to paint river or mountain scenes, low flat landscapes, or even just trees. The list of subjects is endless.

Clearly, if you don't like painting portraits but love landscapes, you will become a landscape painter; or if you like the sea you will become a marine painter. So don't worry if you can't paint everything. Concentrate on your favourite subject but keep trying the others. You will then realize how competent you are at your own subject, and that's good for morale.

The advantages of painting as a leisure activity are that you can paint indoors or outdoors; in a group, with friends, or alone; on holiday, in a traffic jam, or in a car park, even if it's just a pencil sketch or notes on paper, for practice.

The two heavy horses (**fig. 6**) were painted as a sketch, at the Devon Shire Horse Centre – I had 40 minutes to work before they were taken back to their stable. I drew them in pencil and painted them very thinly (more about painting thinly later). The horses were moving all the time but stayed roughly in the same spot, so it helped to be able to paint quickly.

The 'big canvas' myth

One of the biggest obstacles for students who start oil painting is the fact that they believe you have to 'work large', and this puts a lot of them off. Oil painting has a 'big and grand' image. After all, most oil paintings in the public galleries are large, some as tall as eight feet, and that is big by any standards. John Constable's 'Hay Wain', one of my favourite paintings, is 130 × 185 cm ($51\frac{1}{4}$ × 73 in). It is very difficult to work a painting that size outdoors; it isn't practical, so you need a large room at home in which to work. Most students are not used to oil paint, and the brushes, turpentine, linseed oil, palettes, etc. are enough to put anybody off working in oil, especially at home as a hobby. I know that this image of oil painting exists, because my students tell me. So how do we get over it?

First of all, we don't need to paint big. As well as working large, many artists in the past have worked small. Constable, for instance, painted many sketches and preliminary work for his large paintings, very small – about 10 × 15 cm (4 × 6 in) to 25 × 30 cm (10 × 12 in). Naturally, these paintings are not placed in galleries as prominently as the large works but that does not make them any less important. So if we accept the fact that we can paint in oil from as small as 10 × 15 cm (4 × 6 in), we need smaller and less equipment. It makes the preparation and equipment sound almost as simple as watercolour painting, which, apart from cleaning brushes and palette at the end of a session, I like to think it is.

I used to be one of the 'oil means big' people but over the years I have realized that working small in oil is practical, adaptable for outdoor working, enjoyable, instructional, and very acceptable in today's art world. **Figures 7** and **8** show two examples. I suggest that beginners and less experienced students keep within say 41 × 51 cm (16 × 20 in) for 'large' paintings. I will work within this size with you through the course.

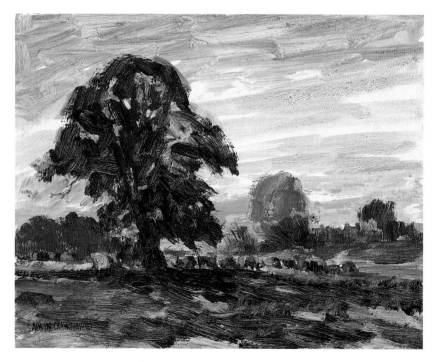

Fig. 7 (above) *Through the grass*. Primed hardboard, 15 × 20 cm (6 × 8 in)

Fig. 8 (left) *Last light*. Primed hardboard, 20 × 25 cm (8 × 10 in)

Part One
GETTING STARTED

MATERIALS

The following is a summary of the oil painting sequence – if you already know it, jump ahead to the next paragraph. You buy your oil paint in tubes, squeeze it on to a palette, then mix the paints with a brush. As you mix you add a medium to your paints – either one to thin the paint or another to make the paint move (spread) more easily; another medium speeds up the drying of the paint and another is used for washing brushes. You don't need to buy all these mediums; I use only two (see page 17).

Colours

There are two qualities of colours: Artists' Professional quality and students' colours; the former are more expensive. I have used Georgian Oil Colours, a students' quality, for the examples throughout this book, and I am sure you will find them perfectly adequate. Illustrated on the palette below (**fig. 9**) are the colours I use for my oil painting, and these are the ones I used for all the work on this course; those on the right of the palette are ones that I use occasionally. All artists use their own range of colours, and no doubt you will want to try other colours. Please use those I have recommended to start with, then experience will take you on to other colours.

It is important to put each colour in the same position on the palette each time. You must be able to put the brush into the colour you want without having to think about it; it must become second nature.

I don't use Black paint, in whatever medium I am working. I believe that if it is on your palette you tend to use it to darken colours and this can make them 'dirty' or lifeless. I mix my 'blacks' (dark colours) by using the three primary colours – red, yellow, blue – and this keeps the 'black' lively, not dull. If you want to use black I suggest you first gain experience in mixing colours from the three primaries; this is explained in Lesson 4.

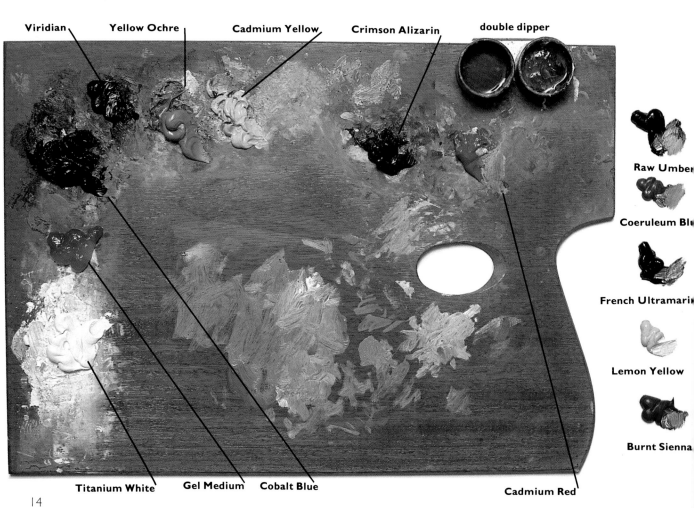

Viridian Yellow Ochre Cadmium Yellow Crimson Alizarin double dipper

Raw Umber

Coeruleum Blue

French Ultramarine

Lemon Yellow

Burnt Sienna

Titanium White Gel Medium Cobalt Blue Cadmium Red

Brushes

It is the brush that makes the marks on the canvas, joining them together to create the picture, so the choice of brush is important. However, a brush that suits one artist does not suit another. If you are a beginner, I suggest you use the brushes that I have used throughout the course until you have gained more experience.

For oil painting there are three basic brush shapes: round, filbert and flat (see **fig. 10**). I prefer the flat brush for general work. The traditional oil painting brush is usually made from hog bristle, but today man-made (nylon) bristles are used – not necessarily to replace the hog bristles but to allow the artist more scope. For detail work you need a small round sable or nylon brush. Series of brushes for oil colours start at No. 1 (the smallest) and usually continue up to No. 12, the largest. You must keep your brushes clean by washing them first in turpentine substitute (white spirit) and then with soap, after a painting session. Put some soap in the palm of your hand and rub the brush into it under running cold water. Thoroughly rinse and dry the brushes before you use them again. While you are working, of course, you wash your brushes only in turpentine substitute.

Palette knife and painting knife

A palette knife (**fig. 10**) is used for mixing large quantities of paint on the palette (I prefer to mix with my brush, and did so for most of the work in this course), for cleaning paint off the palette, and for scraping paint off the canvas if the paint is too thick or if you want to repaint a certain part of the work. I suppose the palette knife is a general-purpose tool, and most likely you will find other uses for it when you are painting.

A painting knife is used for painting – 'palette knife painting' – and has a cranked handle (see **fig. 10**) so that your knuckles do not smudge the wet paint on the canvas as you apply the paint. There are many different shapes and sizes to choose from. I prefer to work with a brush, so my course does not include exercises with a painting knife. If you want to try one, please do.

Palette

Palettes are either oval or oblong and are made from wood or white plastic. The oval ones are called studio palettes but the oblong ones (see **fig. 9**, page 14) are the most popular. Some artists use glass placed on top of a table. You must keep the mixing area clean with turpentine substitute after each painting session.

Fig. 9 (opposite) My palette showing the Georgian Oil Colours I use. The colours on the right I use only occasionally

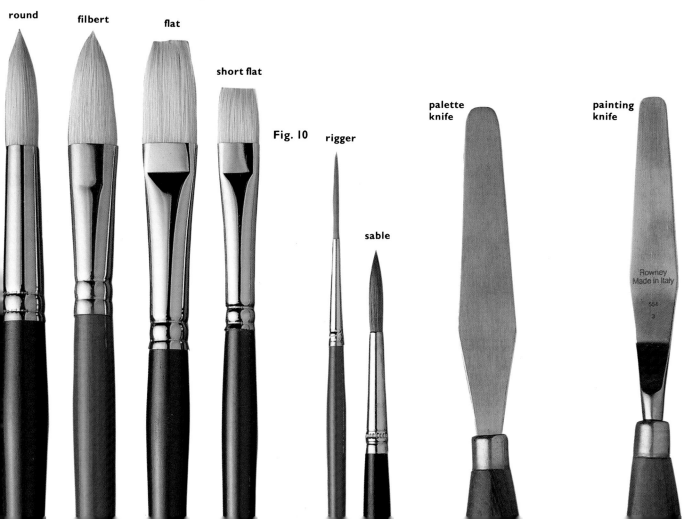

round filbert flat short flat Fig. 10 rigger sable palette knife painting knife

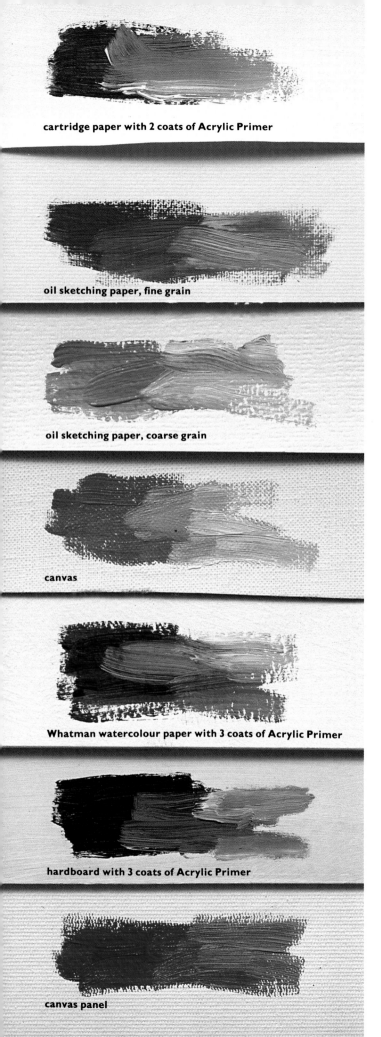

cartridge paper with 2 coats of Acrylic Primer

oil sketching paper, fine grain

oil sketching paper, coarse grain

canvas

Whatman watercolour paper with 3 coats of Acrylic Primer

hardboard with 3 coats of Acrylic Primer

canvas panel

Painting surfaces

The traditional painting surface (support) for oil painting is canvas but, over the years, new surfaces have emerged which are cheaper and allow the artist more choice.

When you buy a canvas it has usually been primed and stretched. Four stretcher pieces are slotted together to form a frame and the canvas is professionally stretched over and fastened on to it. Two wedges are put in each corner of the frame; when they are knocked in with a small hammer the canvas tension increases as the frame becomes slightly larger. When it is 'drum' tight, it is right for painting. You can buy canvas by the yard length and stretch your canvases at home, but I do not recommend this if you are a beginner. In fact, I suggest that to start with you work on other supports and use canvas only for a few 'special' paintings.

On the left are some painting surfaces reproduced actual size (**fig. 11**). I have also applied some paint to help show you the grain of the surface. Take note that all absorbent surfaces, such as paper or hardboard, must be primed so that the oil from the paint is not sucked into it: apply two or three coats of household emulsion paint or Acrylic Primer, obtainable from art supply stores. If you omit to prime the surface, the paint will not 'stick' and could be rubbed off; also it will not spread so easily. Paper was used for sketches by the Old Masters two hundred years ago, so it isn't a new idea for oil painting.

I like to use Whatman watercolour paper, primed with three coats of Acrylic Primer, for paintings no larger than 41 × 30 cm (16 × 12 in). I also like hardboard, primed in the same way; it has a very smooth surface and is quite different from canvas. Canvas boards are simply boards with canvas, already primed, stuck on to one side, and a canvas panel has a simulated canvas surface. Oil sketching paper (rough and smooth grain) is one of the most inexpensive supports; I used a great deal of it at art school. It is primed and ready to work on, and can be bought in pads or sheets.

I recently organized and judged a painting competition for the local BBC radio station, for which one artist sent in a painting done on the back of one side of a cornflakes box. Obviously it had been primed and it gave a reasonable support. I don't know what would be the life of such a painting, but it shows what you could use to practise some basic brush strokes and colour mixing, although I wouldn't recommend it for serious paintings.

Try different supports to find the one you prefer.

Fig. 11 A selection of supports, painted to show the grain

Mediums

There are many different mediums on the market which you mix with the paint either to thin it down or to make it spread more easily.

Turpentine is used to thin down the paint, in particular for under-painting or painting thin lines. Don't confuse this with turpentine substitute (white spirit) which you use to clean your brushes and palette. If you find the smell of turpentine too strong, you can use Low Odour Oil Painting Thinners instead, as I do; this doesn't smell.

Because oil paint takes a long time to dry, I use Alkyd Medium, a jellylike liquid which halves the drying time of oil paint; it also helps to spread the paint. Another drying agent, Gel Medium, is available in a tube.

To sum up, I don't mix my own mediums, and I use only Low Odour Oil Painting Thinners (instead of turpentine) and Alkyd or Gel Medium for all my paintings. I suggest you use those two or three only; they make oil painting much simpler.

Easels

A good strong easel is important because your painting surface must be firm and rigid. Some easels are illustrated in **fig. 12**. If you haven't the room for a standing easel, then a table one is sufficient. You can even put your support on the seat of a kitchen chair and rest it against the back.

Most oil colour boxes use the inside of the lid to hold canvas boards (**fig. 13**). You rest the box on your knees when working outside, on a table when indoors, and the lid becomes the portable easel. Easels vary so much in size, type and cost that I can only suggest you try some out in an art supply shop. Choose one that is steady and, when folded up for use outdoors, is comfortable to carry.

Fig. 12 (below, left) A portable easel and a studio easel

Fig. 13 (below, right) An oil carrying box with a painting held in the lid

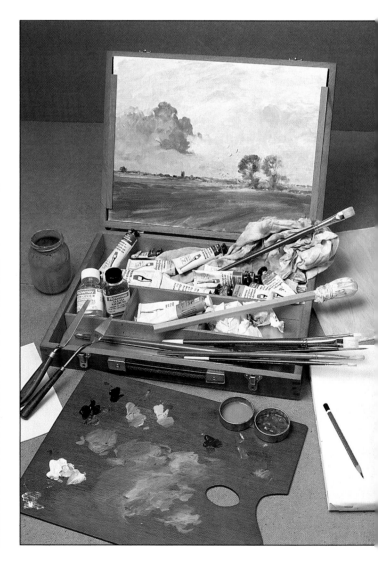

Basic kit

Below is a list of materials you need to start oil painting (see **fig. 14**), and for the work on this course.

The Georgian Oil Colours that I use for the exercises are illustrated in **fig. 9**, page 14.

The brushes you need are: Rowney Bristlewhite Series B.48, Nos. 1, 2, 4 and 6, a sable brush Series 43 No. 6 and a Dalon Rigger Series D.99 No. 2. When you have become familiar with these you can experiment with different ones. If you wish you can buy two brushes of each size, one for dark and the other for light colours. This saves having to wash the brush free of paint already mixed, but if you're like me, you'll start that way and then find you've put the 'dark' brush into the light colour and vice versa!

You will also need a palette, a palette knife with a 7.5 cm (3 in) blade; turpentine or Low Odour Oil Painting Thinners, a bottle of Alkyd Medium and a double dipper for your palette to hold each of them – alternatively use a tube of Gel Medium; a mahl stick for steadying your brush; an old jam jar for turpentine substitute to wash out your brushes; canvas boards or oil painting paper; a paint rag for wiping and cleaning your brushes and hands; and finally, a plastic eraser and an HB pencil.

To cut down the cost you can buy the minimum number of brushes; find your own receptacles to hold the mediums; use a piece of formica or varnished plywood as a palette and a kitchen chair as an easel.

Carrying box

For outdoor work you can use a pochade box, which takes a board up to 25 x 30 cm (10 x 12 in). I use this frequently, but it lacks the easy portability that I like for sketching.

Because I wanted something to pick up and put over my shoulder at a moment's notice, like a camera, I designed the box you see in **figs. 15-17.** If you are any good at woodwork, you could try to make something similar, or adapt a box you already have. Mine measures 22 x 18 x 8 cm ($8\frac{1}{2}$ x 7 x $3\frac{1}{2}$ in) and contains a palette with a single dipper for Low Odour Thinners (use a tube of Gel Medium for driers); five brushes; a pencil; seven tubes of paint; and two painting boards 15 x 20 cm (6 x 8 in). It will also hold your painting rag, and up to four pieces of thin hardboard will fit into the lid, which can be kept rigid at four different angles, without being held, while you are painting. My box has the added advantage that when you have finished painting your colours can be left on the palette because, when the lid is closed, there is enough space between picture and palette to avoid damaging your painting. With this kit you can easily stand up to paint because the box holds all your materials. I used it outdoors for all the 15 x 20 cm (6 x 8 in) paintings in this book.

Fig. 14 The basic materials you need to start oil painting

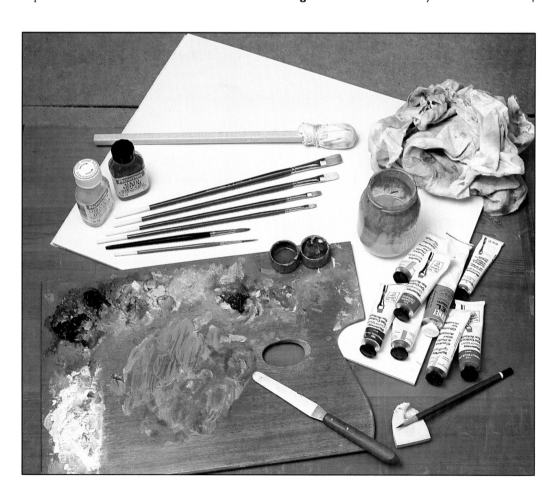

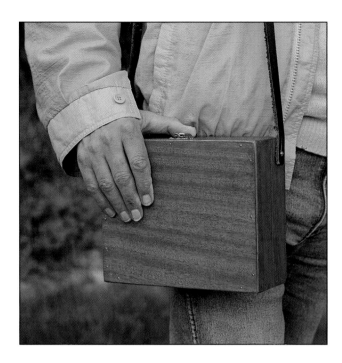

Figs. 15, 16 and 17 It is very useful to find or fashion a portable box that can hold everything you need for small oil paintings. I have attached a strap to mine so that I can even stand up to paint

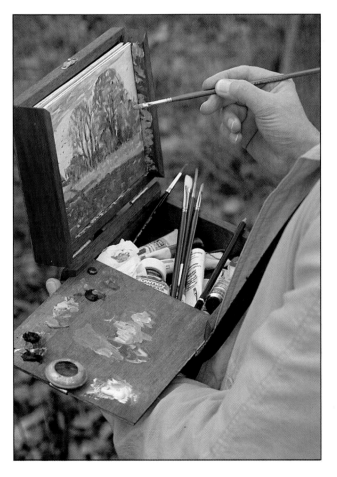

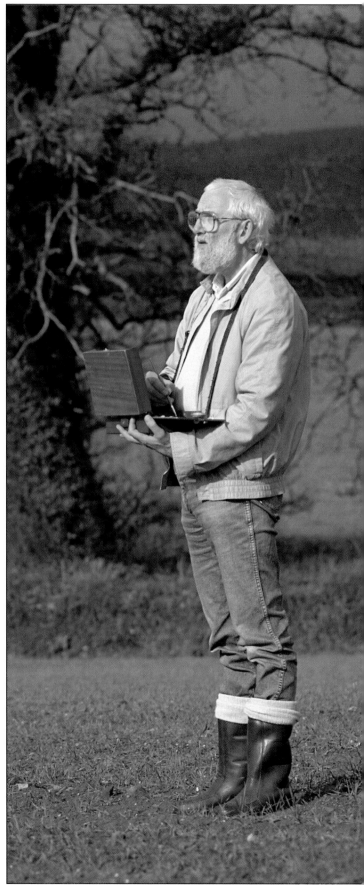

GETTING TO KNOW OIL PAINT

This is where you start to use paint. If you are familiar with oil painting, just miss a few pages and find the exercise that you feel is your starting-point, but don't cheat yourself and start too far into the course. If you already paint in another medium and have decided to take up oil painting, then I suggest you start right here because, although you know about painting, what you have learned in using your medium may not be the same when painting in oils. So relax and start at the beginning as though you didn't know anything. You may find the exercises a little strange at first, but at least you can hide in the corner of your own lounge at home to read and work. If you were on one of our courses you would be in the company of other students – what a thought! Still, we have everyone laughing at the end of the first day.

If you have members of your family to contend with, that can be daunting; you must be prepared for criticism which may sometimes seem unkind. But you'll also receive the admiration of your family and friends as you progress through the course. So you must stick at it.

The hardest part of learning to paint is the 'simple' act of putting paint on to canvas. The first marks that you make are the very beginning of your learning to oil-paint, so you have no need to expect to paint a masterpiece on your very first meeting with paint and brush. After all, no one can learn to play a musical instrument without first learning to play the scales; or take part in a car rally without first learning to drive.

The first thing to do is to put some paint on canvas – well, not canvas at this stage, for you would be conscious of the cost. Use canvas sketching paper, or prime some thick paper or card with Acrylic Primer. You may need to apply up to three coats of primer to stop the paint from soaking into the paper. The object is to have a support that you can paint and doodle on as much as you want, without worrying about the expense. This is what I want you to do when you are ready to paint:

First of all, if it's practical, find a place where you can be on your own. If you have family or friends around, you could become very self-conscious and not make a good start, which is so important. Get into your own world and just play with the paint. Remember, the aim of this lesson is to become familiar with paint, brushes, palette, supports – in fact, with everything you need for oil painting.

Try putting paint on your support with your brush; move the brush around in your fingers as you paint; work it horizontally and vertically. Now mix some Alkyd Medium with the paint; then try adding some turpentine. Now move the paint around with your finger (your finger is a good painting tool, so don't be afraid to use it). Work the paint thickly with the brush; scrape paint off the support with your palette knife. Try wiping paint off with a rag and see what effect it gives; you can make a very interesting background this way. Try all these methods of applying and taking off paint, and use any others you can think of.

What you are creating will look funny, so if the family look at what you are doing and they laugh, then laugh with them. Show them my doodles in **fig. 18** opposite and let them laugh at that! The more you practise like this the better.

When you feel comfortable with a brush in your hand and with the feel of paint on the palette and the canvas; when you yourself **feel** like an artist, although you can't paint a picture yet, then that's the time to go on to the next lesson and enter into a new world of pleasure and fulfilment. But remember, this can be achieved only by practice and perseverance.

Fig. 18 You need to get to know your paint, brushes and supports thoroughly so try every way you can think of to apply paint and even to take it off. Try different brushes and types of support

BRUSH CONTROL

This lesson is devoted to learning how to use the brush to make the marks that we want. By now the brush is not a stranger to you but, like all things new, you need to know how to control it.

In creating a painting thousands of brush strokes are applied to the canvas, yet many of them make the same kind of mark. In another sense, every brush stroke is different, even if we try to copy the previous one, and this is one of the things that makes a painting look alive. So please don't get over-concerned about the 'brush stroke' or try to make an exact copy of the one that went before.

In **fig. 19** there are two types of arrow. **I have used these arrows in various places in the book to help you to understand the movement of the brush strokes. The solid black arrow shows the direction of the brush stroke, and the outline arrow indicates the movement of the brush in relation to the canvas; that is, working from top to bottom, or bottom to top.**

For this exercise I have divided a painting into three parts: background – no detail work; controlled painting areas; and detail work.

The background can relate to the scene (sky, distant hills, etc.) or the painting (the first colours on the canvas, the under-painting). The brush is placed across the palm of the hand and held firmly by the thumb and first finger (**fig. 19**). This position allows you a lot of freedom, and makes it easy to work over large areas of a painting. But you don't have much control.

For controlled painting areas, hold the brush as illustrated in **fig. 20**. This is the way you hold the brush for most of your painting. You will find it easy because it is just like holding a pen or pencil. **Don't hold the brush near the bristles**: hold it 10–13 cm (4–5 in) away from them. This allows you control over the brush strokes, but enough movement of the brush to have freedom and movement over the canvas.

For detail work hold the brush exactly as you would hold a pencil, and this time you can hold it near the bristles as this gives greater control. In **fig. 21**, page 24, I am holding it this way to paint a horizontal thin line, and in **fig. 22** thin vertical lines. The short line I am painting is as far as I can make the brush move down the canvas by just moving my fingers. If I tried to make the line longer it would curve, as the fingers pull the brush into the hand, as you can see on the left of **fig. 22**. This also applies to horizontal lines. Just moving the fingers gives full control and fine detail work – in fact, it is just like writing with a pen or drawing detail with

a pencil. If you want longer horizontal or vertical lines, move your arm and keep your fingers and wrist stiff. In that way your line can be as long as your arm will reach, and that is how I painted the line in **fig. 21**.

When you paint with a small sable or nylon brush for detail work it is important to thin the paint with turps or medium to make it more 'runny', to allow it to flow out of the bristles.

When you try these 'brush holds' out, first try without paint; just get used to working the brush. Your brush strokes will be either vigorous, hesitant, flowing, heavy, delicate or flamboyant; it all depends on you, the way you are made and think. At an art exhibition you can see perhaps a hundred landscapes, and they will all look different, not only because the colour schemes are different but because each artist applies the paint to the canvas in his own personal way. But remember, however you progress in this sense, let your own style develop.

The brush stroke in **fig. 23**, page 24, is called a dry-brush stroke; I believe it is one of the most-used traditional brush techniques. It can create all sorts of effects, and gives movement and life to an area. It can create the illusion of dappled sunlight on water, texture on a plaster wall, a rough earth field, and so on. Fill your brush about one quarter full and drag it across the support from left to right, lifting (less pressure) the brush as it travels along. The paint will hit and miss the canvas, leaving areas unpainted. You will find that this technique happens frequently during a painting – as the brush runs out of paint, for instance. If it happens as a 'happy accident', then use it! If it looks wrong for the painting, simply go over it with more paint.

Where an area of colour stops and joins another colour, there has to be an edge. In **fig. 24** I have shown

Fig. 19 (opposite, above) For large areas of a painting where you need a lot of freedom in your brush strokes but not much control – for example, the background – place your brush across the palm of your hand and hold it firmly with your thumb and first finger

Fig. 20 (opposite, below) Hold your brush as you would hold a pencil, and 10–13 cm (4–5 in) away from the bristles, for the majority of your work so that you have maximum control but sufficient freedom of movement

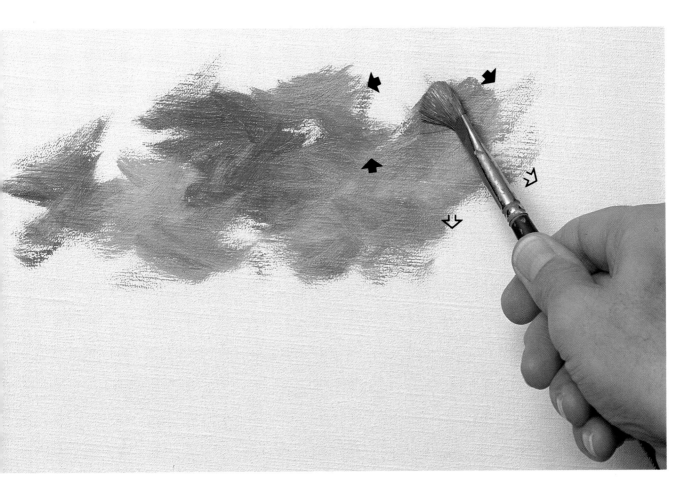

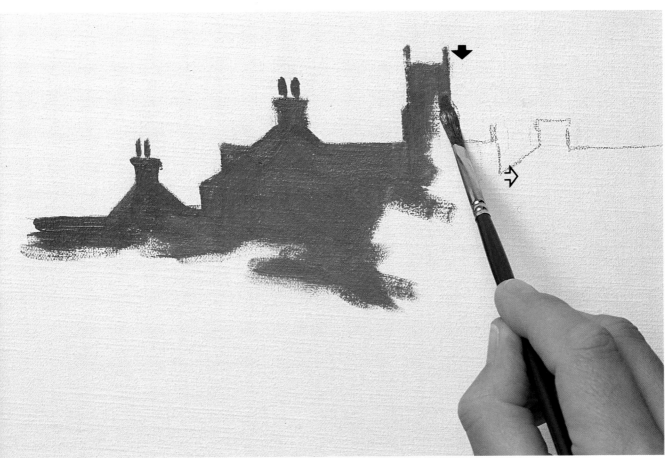

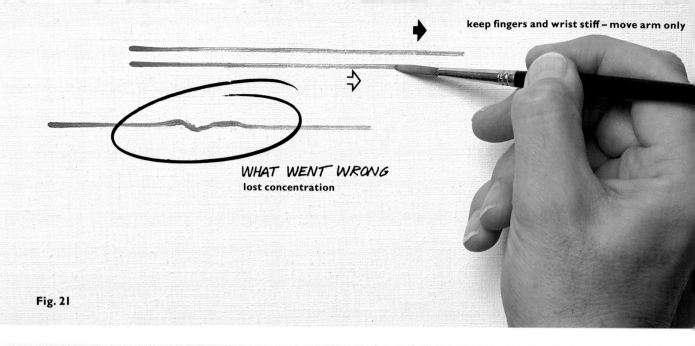

keep fingers and wrist stiff – move arm only

WHAT WENT WRONG
lost concentration

Fig. 21

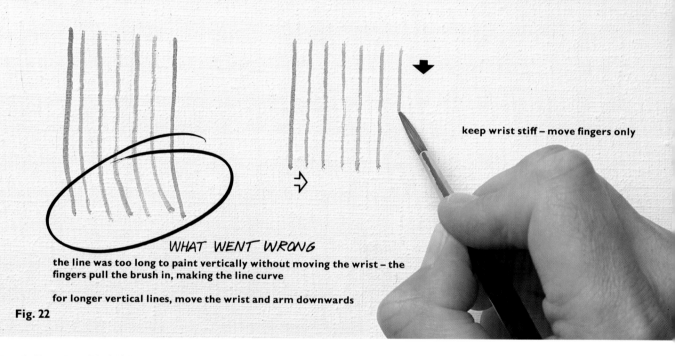

keep wrist stiff – move fingers only

WHAT WENT WRONG
the line was too long to paint vertically without moving the wrist – the fingers pull the brush in, making the line curve

for longer vertical lines, move the wrist and arm downwards

Fig. 22

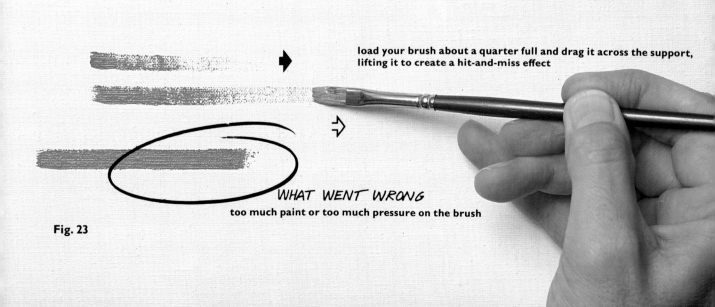

load your brush about a quarter full and drag it across the support, lifting it to create a hit-and-miss effect

WHAT WENT WRONG
too much paint or too much pressure on the brush

Fig. 23

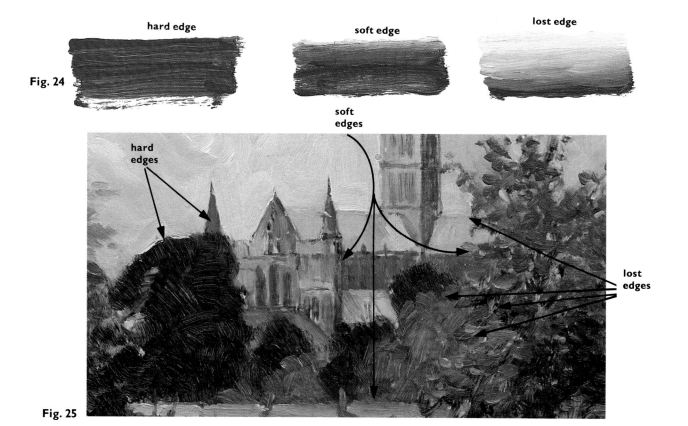

hard edge

soft edge

lost edge

Fig. 24

soft edges

hard edges

lost edges

Fig. 25

three ways of doing this. The hard edge is simply a crisp edge; it makes an accent, a definite demarcation between two colours or areas. The soft edge is a way of making the edge not too prominent. One of its uses is to form the edge of something soft – a furry animal, for instance. Finally, a lost edge is where an edge gradates into another surface, so that in effect there isn't an edge. To create a soft edge, work the brush **over** the desired edge, so that it picks up the paint from the next colour. Exaggerate this to create a lost edge. In **fig. 25** you can see where and how these effects have been used.

Fig. 26 Use a mahl stick when painting over an area of wet paint

I am sure you have been wondering how to control your brush when working over wet paint. The answer is to use a mahl stick. This is a long stick with a pad at one end – mine is 38 cm (15 in) long and has a piece of rag fastened to one end (**fig. 26**). If you worked on very big canvases you would need a longer one. Position the padded end on the edge of the canvas or easel where you can support it with one hand and use it as a rest for your brush hand. If you are working with a pochade box or the Oil Travelling Studio, you can rest your hand on the box, or use your left hand to support your brush hand. You will find this relatively easy to do because you have such a small area to protect in this case.

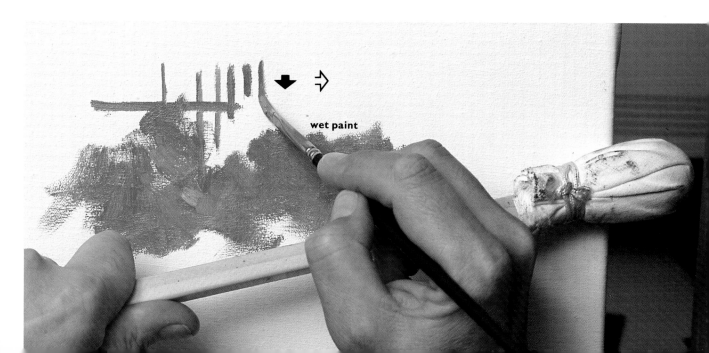

wet paint

MIXING COLOURS

The colours I use are illustrated in **fig. 9**, page 14. If you haven't painted before, it may seem impossible to mix each of the hundreds of colours that surround us by using only the three primary colours, red, yellow and blue. Of course, you can get different reds, yellows and blues – for example, Cadmium Yellow, Yellow Ochre, Lemon Yellow, Naples Yellow – to help mix the colours you want. But in general, using only one of each of the primary colours, you should be able to paint a picture.

Many colours are mixed from only two colours. For instance, green is mixed from yellow and blue, but if you wanted a warmer (browner) green then you would add a little red to your mix (**fig. 27**). If you mixed an equal part of yellow, blue and red, to get the warm green, you would make a dark mud colour. So how do you judge the correct quantity to mix to get the correct colour? You will discover the answer through practice, but here is the golden rule that you must always follow: whatever colour you are going to mix, the first colour you put on to your mixing area must be the predominant colour you are copying.

If you want to mix, say, a reddish orange, you put red into the mixing area, **and then add** a smaller amount of yellow. Don't put the yellow brush straight into the red; work into the red until you have the desired reddish orange (see **fig. 28**). If you start with yellow on the mixing area and then add a smaller amount of red, you will make a yellowish orange. You could eventually get a reddish orange by adding more and more red, but you would mix more paint than you need. It could be very frustrating and time-wasting.

Speed is not an essential attribute for painting, but it helps. For instance, take working outside: the sun moves all the time, changing shadows and light in the scene you are painting. A scene can change: a boat in a harbour can move, a bus can park in front of your view – it's happened to me! It could rain, or you could just run out of time. So all things relevant to speeding up painting should be practised, including mixing the colours you want.

In oil colour we use white paint to make the colours lighter (see the colour chart in **fig. 28**). In fact, you will find that you use up more Titanium White than any other paint.

If you are mixing a light colour, then you must start with Titanium White and mix into that. If you were to mix the colours first and then add Titanium White, because of the strength of the mixed colours, you might need almost half a tube of White to get the required colour pale enough! It sounds obvious, but it still happens to me occasionally.

Although you can paint a picture using three primary colours, a good reason for having other primaries is to be able to use them for local colours. A local colour is the colour of an individual object; for example, a particular blue boat, red car, yellow flower, etc. Take the red car: I use Crimson Alizarin as my primary red, but if the car were a Cadmium Red colour, I would not be able to mix an exact colour using Crimson Alizarin, so I would use my Cadmiun Red for the car. If it wasn't important to be accurate with the car colour, Crimson Alizarin with a little Cadmium Yellow mixed into it would be close enough for my painting.

When you are painting a picture, using the right colour is important, but don't worry about it and keep re-mixing if your colour is a little different from the real-life colour. You don't have to be exact.

Although mixing colours can be frustrating at first, everyone can learn; it is experience that makes it work. Practise; remember that the predominant colour must come first, and don't add too much of the other two colours to start with. Gradually mix them into your first colour until you get the colour you want. You will experience a tremendous feeling of achievement when you are able to mix the colours you want.

When you are mixing colours for this course, it is important to note the first colour I specify (mentioned in the text, or printed on the exercise) as this is usually the main colour of the mix, with other colours added in smaller amounts.

Fig. 27

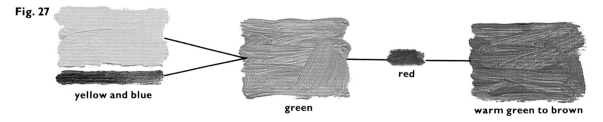

yellow and blue

green

red

warm green to brown

Fig. 28

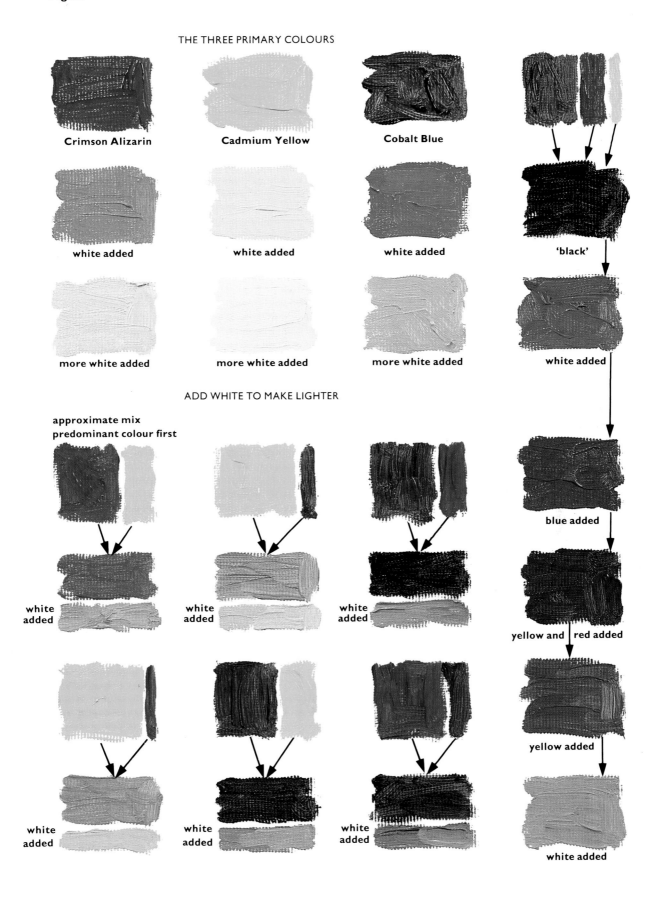

THE THREE PRIMARY COLOURS

Crimson Alizarin

Cadmium Yellow

Cobalt Blue

white added

white added

white added

'black'

more white added

more white added

more white added

white added

ADD WHITE TO MAKE LIGHTER

**approximate mix
predominant colour first**

white
added

white
added

white
added

blue added

yellow and red added

white
added

white
added

white
added

yellow added

white added

FORM AND SHAPE

Up to now you have been concentrating on brush control and colour mixing; whatever shapes you painted were flat. Take a look around you now, and you will see that in fact every object is three-dimensional. So we have to learn how to paint all these three-dimensional objects on a flat (two-dimensional) canvas.

It is simply light and shade that gives form to objects in a painting. Imagine trying to look at a black box in an unlit room that was therefore pitch-black. Naturally, you would not be able to see the box until the light was switched on, casting light and shadows on and around it. You must have looked at objects with the sun behind them – a church steeple, a tree in winter – and seen them only as silhouettes, simply because no light and shadows are cast on them.

Look at **fig. 29**. In A the box is a flat shape, without form. On its own, no one would recognize it as a box, which shows how much we need light and shade – 'light against dark' or 'dark against light'. Look what happens when I paint two sides of the box in another tone (B): the top of the box appears, the top being lighter than the two sides (light against dark). In C I have painted the right side of the box darker still, which makes the front and side panels recognizable. Using light against dark, I have created the illusion of a three-dimensional box.

Now let us see what else can be created from the box. At the top of the page I have used just two tones and created a box without a lid (**fig. 30**D); in E the box is on its side and open at both ends. Stop to think for a moment at this point: from only one shape, a shape

that is unrecognizable, I have created a box in three different forms, only by painting surfaces dark against light, or light against dark.

Now let us take it a stage further: in F I have painted a dark box on a light background, and in G I have made exactly the same box look like a light one on a dark background. Students on my courses are fascinated to see how logical this is; just paint a dark area against a lighter one, or vice versa, and it gives the illusion of form. I have done just this in **fig. 31**H, and it looks like a folded card.

The same principles apply to a sphere. In I the sphere is flat because it is in silhouette. In J I have added shadow to give it form. Obviously, the shadows on a sphere are more subtle than on a box, but the principle is the same: light against dark.

Take a good look at **fig. 32**. I painted this as an exercise to show students how a picture is built up from areas of light against dark to create the illusion of three dimensions. Look carefully at objects around you and analyse their light and dark areas, then practise painting them. You will find this lesson exciting, because you are creating the illusion of a three-dimensional object on a flat canvas.

Fig. 29

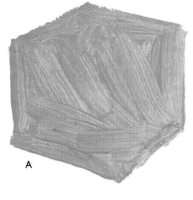

A

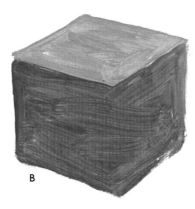

B

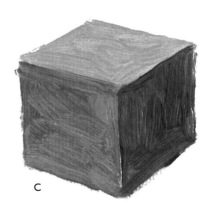

C

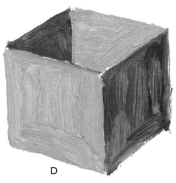

Fig. 30

D

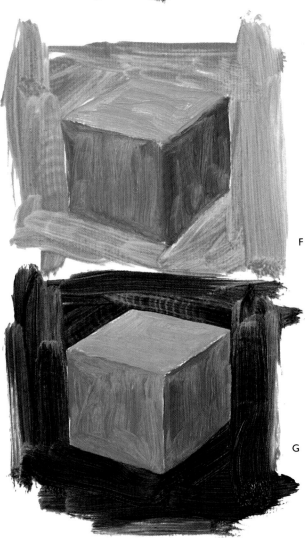

E

F

G

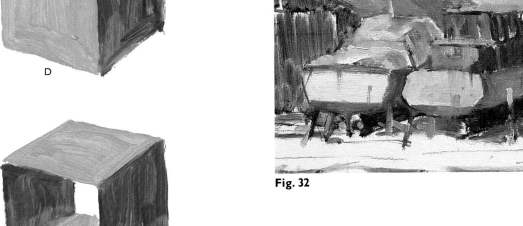

Fig. 32

Fig. 31

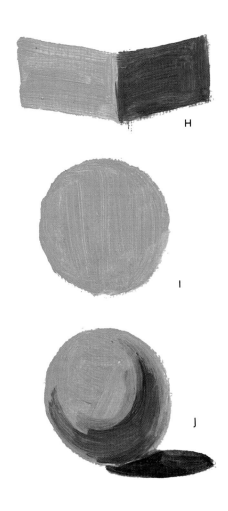

H

I

J

29

LESSON 6

TONAL VALUES

When we are looking at a subject or scene it can be difficult to decide which are the darkest and lightest areas; or, more important, which are the darkest and lightest areas in relation to other areas in the same scene. This can be distorted by the colours of objects and also what we have grown up to believe. We have always known that lemon yellow is a bright, light yellow; but if it is in shadow, it can appear to be very dark. In the same way, a dark blue can, in certain circumstances, appear very light. For instance, a dark blue car bonnet with the sun reflected off it could look very bright and could be one of the lightest areas in your painting. So do not assume that some colours are always light and some always dark.

In the previous lesson you learned to show the form of objects by using light against dark. Now we have to decide how dark or how light objects are in relation to one another (tonal values). Look again at **fig. 30** on page 29: box F appears dark on a light background; box G is tonally lighter in its surroundings because it is against a dark background, yet it is the same box as F.

To see the tonal values in a scene, screw up your eyes when you look at your subject. Make a habit of doing this because it removes some of the middle tones, so you see only the real darks and lights. Some objects will merge together because, although they may be different colours; they have the same tonal value. The word 'value' in art simply means the relative lightness or darkness of tone or colour. If we don't get our tonal values correct in a painting, then it will appear flat and lacking in form.

To help with tonal values make a scale, as I have done in **fig. 33**. First paint the colour you want (green), then mix and paint two tones lighter and two

darker. Repeat, this time using Lemon Yellow or, if you haven't bought this yet, Cadmium Yellow. Paint in your mid-tone, then mix and add two lighter and two darker tones. Add Titanium White to make the two lighter tones, and a little Cobalt Blue and Crimson Alizarin to make the darker tones.

In **fig. 34** I have painted a lemon in two stages, using the full range of tonal values, 1 to 5. In the one that went wrong, there was not enough 'dark' yellow no. 1 to show the rounded form of the lemon. Students are often afraid to make light objects dark enough in the dark areas, and because of this the painted object looks flat or incorrectly formed. Find a lemon or apple and put it on a table, screw up your eyes and observe how dark the shadow area is where the lemon is in contact with the table.

In **fig. 35** I have painted the lemon in low key, as though it were in shadow, using the tonal scale only from 1 to 3; the lemon below it is painted in high key, as if it were in soft sunlight, using the scale from 3 to 5.

You don't need to make any more than five tones because you will be making other tonal values as you work your brush on the palette and the canvas – wet paint will mix into wet paint.

First practise with the guide on simple objects, such as the lemons, so that you get used to the meaning of tonal values on your work. Later, you can use the scale as a mental guide while you work; it will be a tremendous help to you in creating objects that are solid and three-dimensional.

By the way, when you paint your tonal guide for the lemon, remember to mix enough paint in the five values to practise the lemon exercises!

Fig. 33 Tonal guide

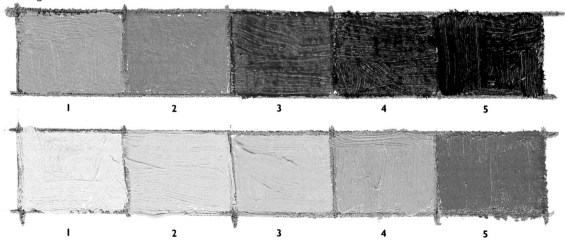

Fig. 34

Fig. 35

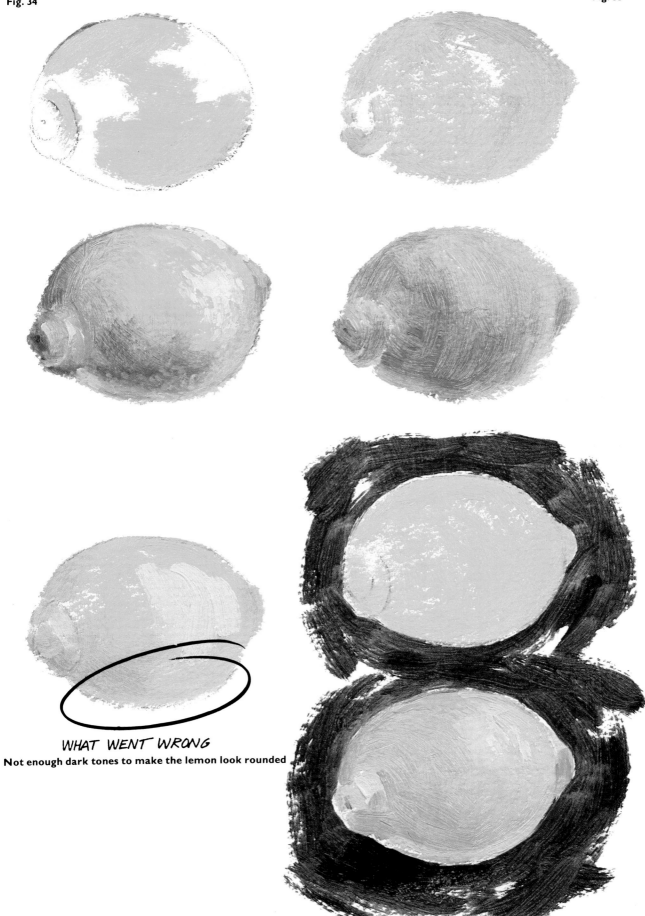

WHAT WENT WRONG
Not enough dark tones to make the lemon look rounded

DRAWING IN YOUR SUBJECT

The illustrations in **figs. 37–40** do not represent four stages of a painting; they show four different ways in which you can draw in your painting before using paint in the normal way. Some artists paint straight on to the support without drawing at all, but I suggest you wait until you are more experienced before you try it.

You can draw in the picture with a pencil (**fig. 37**). Don't try to put in detail; just draw the main areas. I don't like using charcoal (a traditional way of working) because it can make the paint dirty, and I find it too clumsy for working small.

A common way of starting is to draw in the picture with a brush (**fig. 38**). I use Cobalt Blue and a touch of Crimson Alizarin mixed together with plenty of Low Odour Thinners, so that it is like working with watercolour. You will find this paints very easily on to your support and it dries very quickly – in about 10 to 20 minutes. You will find that the blue line will show through in places, and will help to give your painting character. Also, as you paint, the line stays visible longer than a pencil line. If you wish, you can start to paint over the top of your lines before they are dry but, depending how wet they are, they will mix into your paint and you could lose some of them.

Another method is to paint in with a brush, as shown in **fig. 38**, and then paint in the tonal values

with the same colour, making them lighter by adding more Low Odour Thinners (**fig. 39**). Make sure you get the very-darks painted, leaving the support unpainted for the lightest lights.

Finally, you can draw in with a brush and then with colour mixed with plenty of Low Odour Thinners (**fig. 40**). This mix is known as a turpsy wash. Paint the picture as though you were painting it in watercolour: don't use Titanium White. Put all this work in freely, without any thought of detail, and it will give you a perfect starting point. After this, you will be painting a scene that is by now familiar (this is very important), and you will have a tonal guide and a rough colour guide to work over.

Let the turpsy wash dry but don't worry if, because of conditions, you have to start painting over before it is dry; this is quite acceptable. If some of your under-painting (turpsy wash) is left uncovered by paint, either by accident or because you like it, this can be part of the painting. You don't have to cover up every bit laboriously.

Some artists paint a turpsy wash colour over their support before starting; usually a warm ochre or sienna colour. This helps to give the painting an overall colour. Where the background is left showing between brush strokes of paint, and where the paint is thinned, the background shows through as a constant colour. Look at the red and white boat in **fig. 158**, page 100, and you will see how much I let the turpsy wash of Yellow Ochre with a touch of Crimson Alizarin show through, sometimes by accident, and frequently by design.

I often use acrylic colour for the background wash; it dries quickly and does not pull up and mix with the oil paint when it is painted over. If you decide to use it, be sure to use a different brush because you mix acrylic paint with water and it won't mix with oil.

I painted this sequence for my TV series, 'Crawshaw Paints Oil', made by TSW – Television South West.

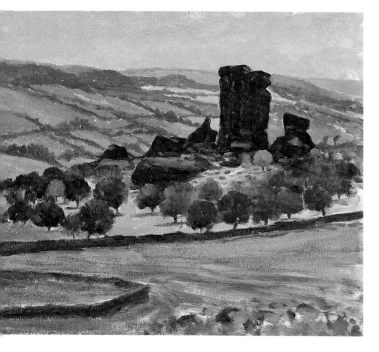

Fig. 36 *Vixen Tor, Dartmoor*. Primed Whatman paper, 25 × 30 cm (10 × 12 in)

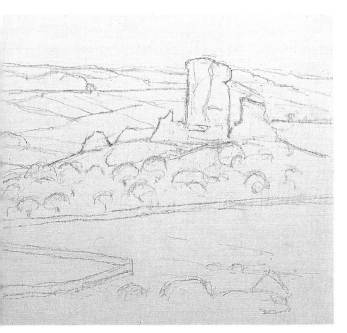

Fig. 37 The main areas drawn in with a pencil

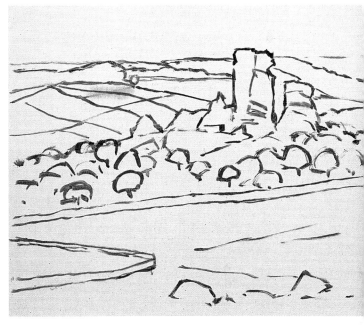

Fig. 38 The same scene drawn in with a brush and a turpsy mix of Cobalt Blue and Crimson Alizarin

Fig. 39 An alternative method of drawing in is first to paint in the main areas with a brush, then add the tonal values with tones of the same colour

Fig. 40 A fourth method is to draw in with a brush, then with colour mixed as a turpsy wash

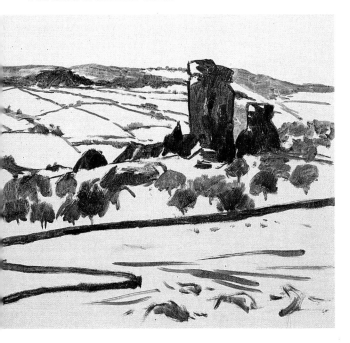

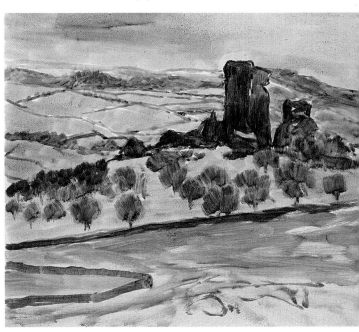

Part Two
SIMPLE EXERCISES

PAINTING WITH THREE COLOURS

This is the lesson where you actually paint real objects, the one you have been waiting for. I am sure most of you have been practising but there is usually someone who lets a lesson slip by without paying much attention. If this happens on a course, I am there to put them back on the rails. Here, I can only trust you to practise each lesson. Reading and learning the theory take you only part way there; the practical side of each lesson is very important, even if at the time it seems impossible to do.

Take brush strokes, for example. After reading my instructions on holding the brush and the method of applying the paint to the canvas, if you tried it half a dozen times, then said to yourself: 'OK, I know what he means; on with the next brush-stroke', that is not going to give you **confidence** with your brush strokes when you come to paint a picture. You must practise and practise until you don't have to think about what to do, to the point when it becomes second nature. All car drivers know, of course, that it was constant practice and patience that eventually got them through until driving became automatic. The same will happen with your painting. If you practise sufficiently you will have a breakthrough which will give you a feeling of elation, and the inspiration and drive to go on to the next stage. It may be when you are mixing colours first, or when you find you are handling a brush with the confidence of a pencil, and so on, but it will certainly happen.

Now, on with this lesson. Before you start to look around for objects to paint, first copy the exercises in **figs. 41–45** on pages 36–40. These will give you confidence for the real-life objects.

I am allowing you to use only the three primary colours because this is the best way to learn how to mix colours. If you use a tube of brown paint every time you want a brown colour, you will not learn how to mix one; worse, all the brown colours on your painting will be identical. But if you mix your brown from the three primary colours, you can warm up the brown by adding a little more red, make it cooler by adding a little more blue, make it yellowish-brown by adding more yellow, and so on. Your brown will be much more subtle, much nearer to life, and your colours will be more vibrant.

I am not suggesting that you don't use ready-mixed colours – after all, I use a green on my palette – but to learn how to mix your colours you must work with the three primaries first. As you gain confidence and experience, you will try ready-mixed colours and whatever you decide to use is fine. Remember, all artists are individual and most have their own favourite colours to work with.

Incidentally, after my students have done their first three-colour exercise, they are thrilled. Most of them never imagined they could do it, and some prefer their paintings using only three colours to the ones they had done previously, using many more colours. Those who had been using as many as 15 to 20 colours were the ones who were truly amazed at what they had achieved with only three.

I have chosen easy-to-draw objects for these initial exercises. The parsnip, for instance, will still look like a parsnip, even if you draw some of the 'bumps' in the wrong places! There's a good reason for my choice: your first 'real' painting must be a success. This will give you confidence to go on to the next, and your confidence will continue to grow. You will relax and your painting will improve quickly.

I have painted each exercise in stages. These are simulated, but the demonstration exercises at the end of the book have been photographed at each stage of their development, so that you can see how the **same** painting progresses until it is finished.

After you have practised these exercises, find some simple objects at home and try painting from real life.

Fig. 41

Crimson Alizarin **Yellow Ochre** **Cobalt Blue**

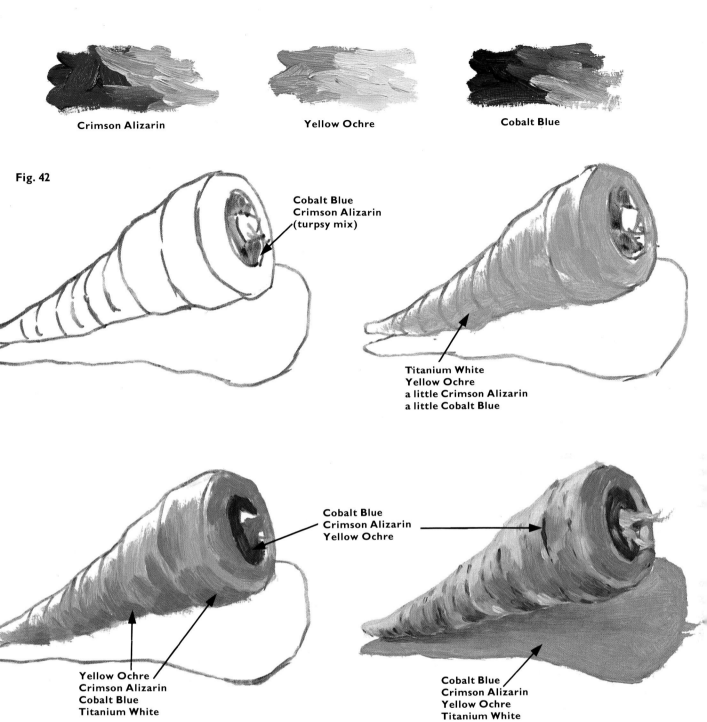

Fig. 42

Cobalt Blue
Crimson Alizarin
(turpsy mix)

Titanium White
Yellow Ochre
a little Crimson Alizarin
a little Cobalt Blue

Cobalt Blue
Crimson Alizarin
Yellow Ochre

Cobalt Blue
Crimson Alizarin
Yellow Ochre

Yellow Ochre
Crimson Alizarin
Cobalt Blue
Titanium White

Cobalt Blue
Crimson Alizarin
Yellow Ochre
Titanium White

WHAT WENT WRONG

It's a good parsnip colour but not enough
dark colour (tone) underneath to help it look
round – the natural markings help the eye to
see it as round but that's not enough

Crimson Alizarin

Cadmium Yellow

Cobalt Blue

Fig. 43

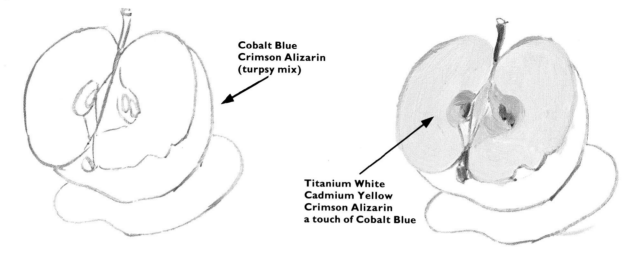

Cobalt Blue
Crimson Alizarin
(turpsy mix)

Titanium White
Cadmium Yellow
Crimson Alizarin
a touch of Cobalt Blue

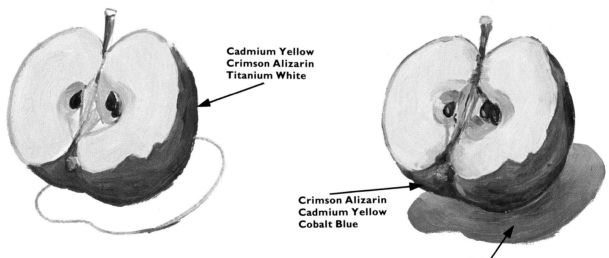

Cadmium Yellow
Crimson Alizarin
Titanium White

Crimson Alizarin
Cadmium Yellow
Cobalt Blue

Cobalt Blue
Crimson Alizarin
Cadmium Yellow
Titanium White

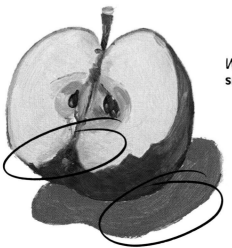

WHAT WENT WRONG
Shadow too grey and red of apple needs more highlights

38

Crimson Alizarin

Yellow Ochre

Cobalt Blue

Fig. 44

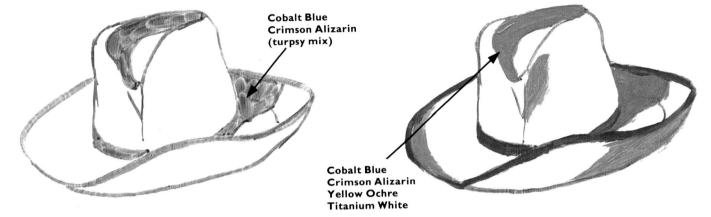

Cobalt Blue
Crimson Alizarin
(turpsy mix)

Cobalt Blue
Crimson Alizarin
Yellow Ochre
Titanium White

**Titanium White
Yellow Ochre**

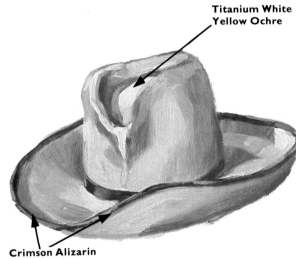

Titanium White
Yellow Ochre

Crimson Alizarin
Yellow Ochre
Cobalt Blue
a touch of Titanium White
highlights – less Cobalt Blue, more Titanium White

WHAT WENT WRONG

Lost definition and shape – this is not wrong in a painting, in fact we try
to achieve it in certain places (lost edges) but that was not the objective
here

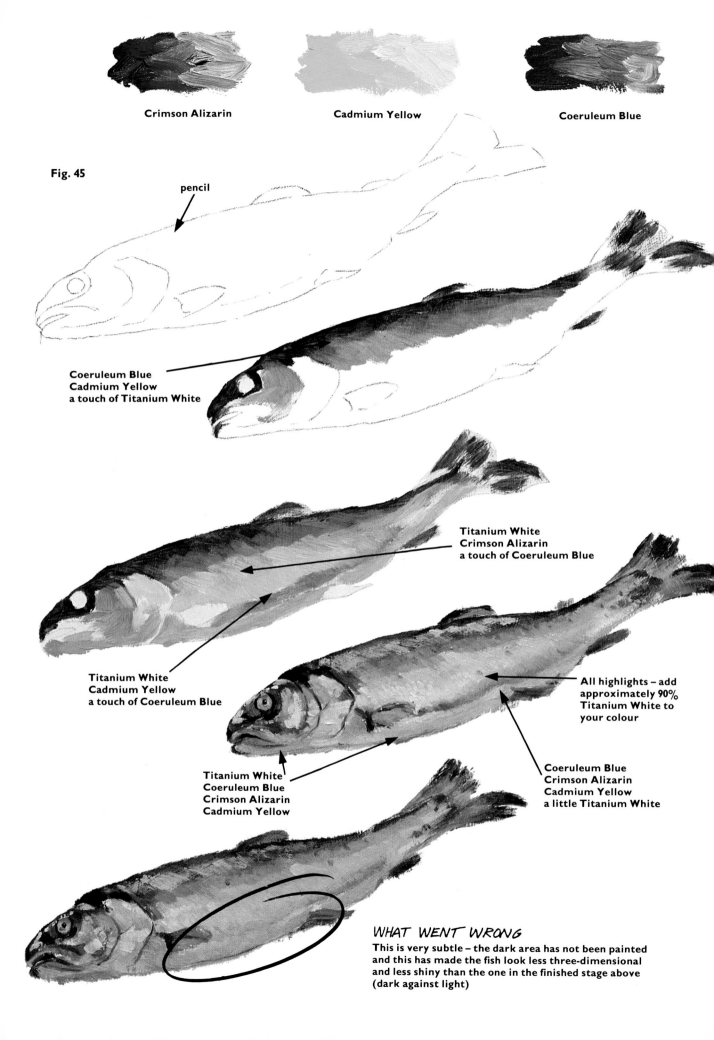

Crimson Alizarin

Cadmium Yellow

Coeruleum Blue

Fig. 45

pencil

Coeruleum Blue
Cadmium Yellow
a touch of Titanium White

Titanium White
Crimson Alizarin
a touch of Coeruleum Blue

Titanium White
Cadmium Yellow
a touch of Coeruleum Blue

All highlights – add
approximately 90%
Titanium White to
your colour

Titanium White
Coeruleum Blue
Crimson Alizarin
Cadmium Yellow

Coeruleum Blue
Crimson Alizarin
Cadmium Yellow
a little Titanium White

WHAT WENT WRONG
This is very subtle – the dark area has not been painted
and this has made the fish look less three-dimensional
and less shiny than the one in the finished stage above
(dark against light)

STILL LIFE IN THE GARDEN

Working outdoors presents many painting and
practical problems, and these are discussed in
Lesson 10. As a step towards gaining sufficient
confidence to work outside, painting a still life in the
garden has great advantages. If you haven't a garden of
your own, use that of a friend.

The attractions of working in the garden are that you
do not waste painting time in travelling; you don't
spend hours walking around looking for a subject –
there isn't room in the average garden; if it rains you
can very quickly get your work and materials indoors;
you won't be disturbed by strangers looking at your
work (if this worries you); you can always slip inside
to make a drink when you reach a thinking/resting
point on your painting; and if it turns cold, you can
easily fetch warmer clothing from the house. Above
all, you don't feel as though you are working in a
strange place.

The obvious disadvantage of working in the garden
is the subject matter. You can't paint a seascape, or a
country river scene from your garden if you live in a
city. Your choice of subject is restricted by the type of
garden you have and where you live, so I must leave
that to you.

Before you go out to start work in the garden, copy
the garden scene I have painted as an exercise for you
(**fig. 49**, page 43). Actually, this is not a subject from
my own garden but a garden I saw in Tuscany while
June and I were running a course there. I thought it
made a good example for this exercise. It is an intimate
part of a garden; in fact, if you look closely and
carefully at small areas of any garden, you will find
plenty of subjects to paint. The sunlight and strong
shadows inspired me to paint this, and of course the
pink colour of the flowers and the orange of the plant
pot against all the greens.

Give the board a wash of Yellow Ochre with a little
Crimson Alizarin (Stage 1, **fig. 46**). Then draw the
main areas of the picture freely with a 2B pencil. Using
a turpsy wash of Cobalt Blue and Crimson Alizarin, and
your No. 4 brush, paint the dark areas. This
distinguishes the shadow areas from the sunlit areas.
Don't put them on too carefully; look at mine (**fig. 47**)
and you will see just how freely I painted them.

In Stage 2, paint in the plant pot with your No. 1
brush, using Cadmium Red, Cadmium Yellow, a little
Titanium White and a little Cobalt Blue for the dark
side (**fig. 48**). For the light side use much more
Titanium White and no Cobalt Blue. Next, paint the

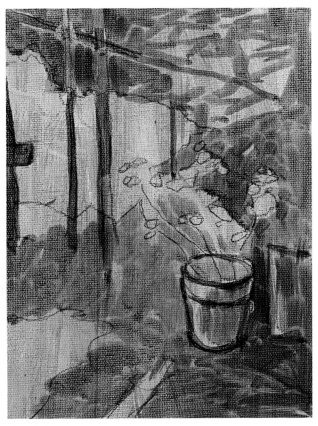

Fig. 46 Stage 1

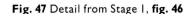

Fig. 47 Detail from Stage 1, **fig. 46**

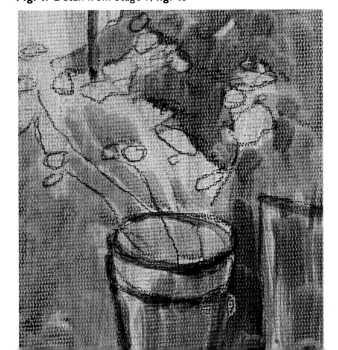

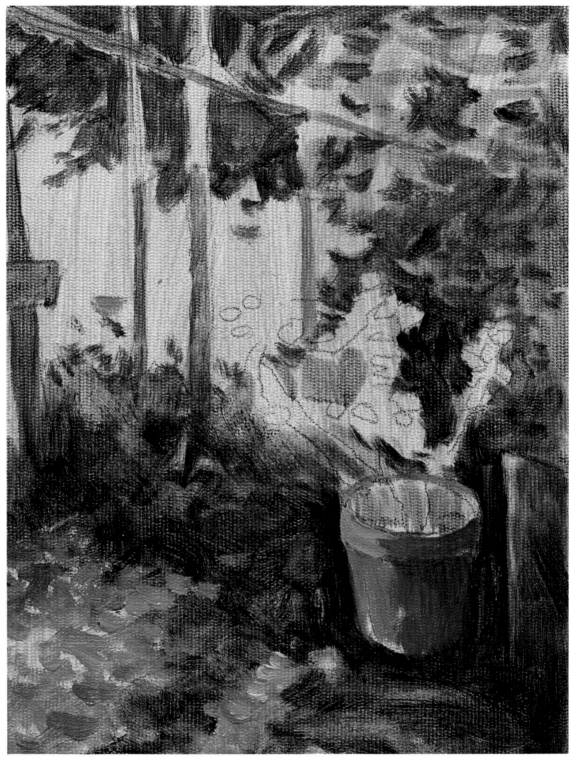

Fig. 48 Stage 2 (reproduced actual size)

shadow areas darker with your No. 4 brush, and keep the paint thin (turpsy). Now paint in the sunlit green at the bottom of the painting, using a mix of Cadmium Yellow, a little Cobalt Blue and Titanium White. Leave some small areas of the Yellow Ochre under-wash unpainted, either by happy accident or by design. This helps to break up the colours and also gives the illusion of sunlight.

Using your No. 1 brush and a mixture of Titanium White, Cadmium Yellow and Cobalt Blue, paint in the sunlit area behind the posts (Finished stage, **fig. 49**). Keep this colour a little on the blue side (cool) to give

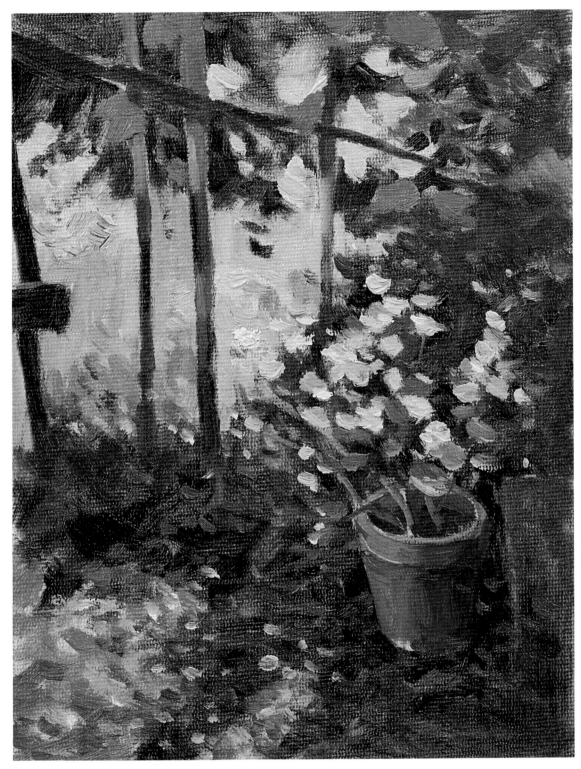

Fig. 49 Finished stage. Canvas panel (reproduced actual size)

the impression that this area is in the background. With the same brush and a mix of Titanium White, Cadmium Yellow, Crimson Alizarin and a little Cobalt Blue for the light areas – less Titanium White for the shadow areas – paint in the posts. Now mix a light and a dark green for the vine leaves at the top, and some warm light green for the sunlit area at the bottom, and paint them. Finally, with the same brush, put in the geranium plant, using Titanium White, Crimson Alizarin and a touch of Cadmium Yellow, filling in any spaces between the flowers and the background with dark greens.

Part Three
WORKING OUTDOORS

WORKING OUTDOORS

If you have worked through the exercises so far – and practised – you should now feel confident about mixing your colours, starting a painting, and applying paint to canvas. So you are now ready to begin painting outdoors, beyond your garden.

Up to now, when you have been painting you have had all the elements under your control. Now, you will have to contend with nature and your fellow human beings. How do you cope with people watching you paint? For the extroverts there is no problem; they are quite happy to work in front of an audience. For the majority of students, however, the first trip outdoors can be frightening. I am one of the lucky ones; it doesn't worry me, as you can see in **fig. 50** – so long as I know what I am doing. You must have enough knowledge to attempt to paint the scene in front of you, so that if people come and watch, you will be **painting**. It doesn't matter whether it's a good painting or not; the onlooker will see you as an artist and will accept the quality of the painting. After all, as far as they are concerned, you could still have a lot of work to do to finish it; they don't know. The majority of people who come to watch you work will admire

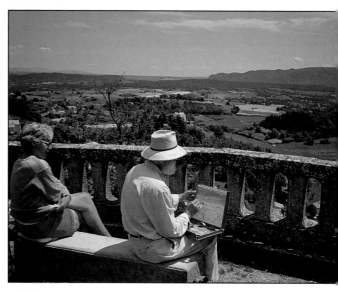

Fig. 50 (above) Alwyn Crawshaw painting outdoors in Provence
Fig. 51 (below) *Mist in Webburn Valley, Dartmoor*. Primed hardboard, 25 × 30 cm (10 × 12 in)
Fig. 52 (opposite) *Spring day, Metcombe*. Primed hardboard, 25 × 30 cm (10 × 12 in)

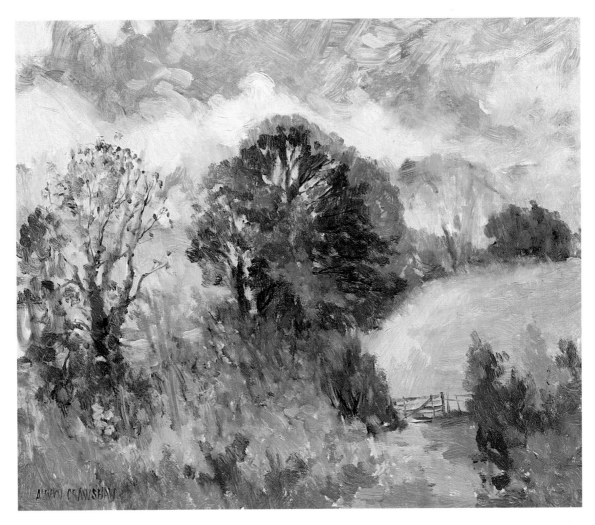

you, not only for being an artist, but because you are working outside, where people can watch while you work. Remember, they see you as an artist. They can't see your tummy turning over and your mouth growing dry. If the tension makes you put a wrong colour on the canvas, they won't know, so don't worry. Try to chat to them, and this will relax you.

Children can be a problem, unless you react tactfully. They usually say either 'My sister can paint better than that!' or 'That's fantastic! You must be a real artist.' In the first case, agree and pretend that you are second-best; in the second case, answer confidently, 'Yes, I am, but I am still learning.' We can always do with comments of the second type; they are real confidence-boosters.

If you are really worried about working outdoors, then go with a friend, even if he or she does not paint. It's amazing how much confidence this gives you.

The picture in **fig. 51** I painted on Dartmoor late one afternoon. The sun was low, and just as I had painted in the distance (fields and moorland) and the rocks, a mist came down and completely obscured the background. Had I been working in watercolour it would have been difficult, if not impossible, to change the mood or the content of the painting, simply

because of the nature of the medium. But with oil, while it is wet you can move the paint around on the canvas, and this is what I did. I blended the background with the sky to give the illusion of mist, and it worked. I don't advocate changing a painting's mood as the scene changes; in fact, once you have started you must keep to your original objectives. However, when the mist came down, I had nothing to lose. Ironically, a few minutes after I had finished the painting, the mist miraculously cleared!

When working outdoors I find that oil is better for creating the mood of a scene, rather than working in detail. In **fig. 52** is a painting I did as a half-hour exercise (more about that in Lesson 15), aiming to capture the blustery spring day. You can see that there is virtually no detail, but I have created the impression of a spring day.

In contrast, I painted the scene in **fig. 53**, page 48, on a very hot summer's day. The temperature was over 30 degrees, there was no wind, and the trees were hanging very still and heavy, in strong shadow. The river, dark and sombre, was moving very slowly. The only real movement in the scene came from the flies and insects that always managed to find me to land on! I like the painting, but I wonder whether I painted it in

too low a key, and whether it would have been better a little lighter. But this is how I saw the scene at the time, and this is the object of working outside: to paint the scene as we see and feel it. We can experiment at home, where we have the time and the paintings done outside can act as guides and as inspiration.

Now let us consider some practical points about painting outdoors:

1. Warmth
2. Equipment
3. Spot
4. Comfort
5. Observation

You can remember this list by the mnemonic WESCO. The rules are simple, mostly common sense, and make working outdoors much easier.

Warmth It is essential to keep warm when you work. You need your mind and hands to function at their best to create a painting, and you can't expect them to do this if you are cold. When it is very cold I use gloves without fingers. These keep my hands reasonably warm but, most important, my fingers are not covered and so they are sensitive to the brush.

Equipment The equipment you need is covered in Lesson 1. Always check your equipment before leaving home. It's no good finding a fabulous spot, preparing your drawing ready for painting, and then discovering a flattened, squeezed-out tube of Titanium White in your kit, instead of the new tube you intended to put

in after the last trip. It's easy to do – we've all done it!

It is equally important not to take too much equipment. Remember that you have to carry it sometimes half a mile or more before you find a painting spot, and not always over level ground. If you take a pochade box or something similar, you will have no problems; but if you take an easel, make sure it's a lightweight one. Take only what you are going to use, with obvious duplication for safety; for example, two supports to work on. You need to be able to look for your painting spot in reasonable comfort and get there without being too tired to paint.

Spot Deciding on a painting spot can be the most frustrating part of working outdoors, for professionals as well as amateurs. It calls for much self-discipline in order to avoid losing valuable painting time. We are all guilty of 'looking round the next corner', myself included. When you see a scene that inspires you, paint it. Don't go looking for a better one. The fact that it inspires you means that you want to paint it, so why look for something better? Do remember this. If I didn't work to this simple rule, then I would have wasted a lot of time outdoors looking for scenes instead of painting them.

Comfort A professional pianist wouldn't sit on a wobbly stool when preparing to play in an orchestra. His stool would be at the perfect height and distance from the piano, his hands would be warm and supple, he would be in a position from which he could see the conductor easily, and so on. He would be completely comfortable. For artists to obtain the best results the same rules of comfort apply. You must sit on a comfortable stool or chair. If you are resting your canvas on your knees (a pochade box or something similar) and it proves too heavy, take the painting equipment out of the box and put it on the ground. Don't have your stool perched at a precarious angle; after an hour or so you could find yourself becoming very uncomfortable. If you are using an easel, make sure it is safe and that you don't have to keep hold of the canvas to steady it or stop it blowing away.

Observation This is perhaps the most important rule of all and it applies to indoor painting as much as to outdoor work. Observation is looking at things more carefully. If you glanced at a group of people boarding a pleasure boat, and watched the boat casting-off and leaving the harbour, that is the information your brain would accept – insufficient, unfortunately, to make a painting. For that you have to observe. If you observed the same scene from an artist's point of view, you would see a group of **young** people, mainly **boys**, in **brightly coloured** holiday clothes, climbing **two at a time** on to a **blue and red** boat, moored with **thick orange-coloured** ropes; on

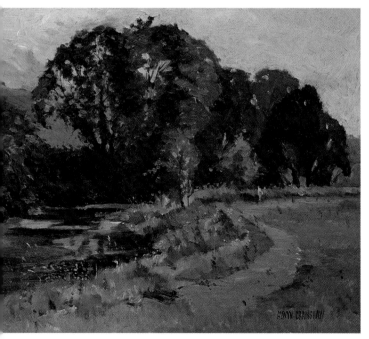

Fig. 53 *Summer on the River Otter*. Primed hardboard, 25 x 30 cm(10 x12 in)

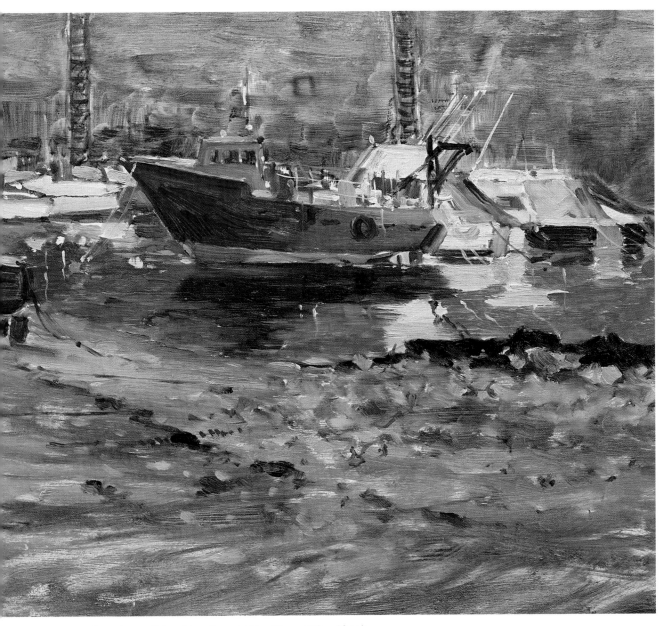

Fig. 54 *Brown boat, Jersey*. Primed hardboard, 25 × 30 cm (10 × 12 in)

the deck, made **of polished wooden planks, is a small black dog**; and so on. To paint a scene we need to know what is there. So take time, five to fifteen minutes if necessary, to observe your scene and familiarize yourself with it, before starting to paint.

The painting in **fig.54** shows a harbour in Jersey. Whatever painting position I found, the large brown-coloured boat was always prominent. It's not the best looking boat to paint, but it was too late to go anywhere else. Even so, I don't dislike the painting, and I particularly like the white and blue boats behind and to the right of the brown one; for me, that area alone made the painting worthwhile.

Don't paint a 'moving' scene on your first few outdoor trips. Find something static, such as a landscape with trees that don't move, not a busy harbour scene.

PERSPECTIVE

Don't skip over this lesson as I am sure some of you would like to do. Well, that's understandable. I must admit that I would hesitate over painting something very difficult, such as a building with complicated perspectives. But if you learn some of the basic rules you will be able to draw and paint more easily. Some students have a natural ability to draw in perspective; if you are one of them, this lesson will be relatively easy. If you are not one of the lucky ones, then spend some time to practise this lesson.

We will begin with the eye level. If you look out to sea, the horizon is always at your eye level, whether you stand on top of a cliff or sit in a rowing boat. Hold a pencil horizontally at arm's length and look past the pencil to the horizon; the two will be aligned. So the horizon is the eye level. Naturally, there is no horizon in a room but there is still an eye level. Hold your pencil horizontally at arm's length and look past the pencil to the opposite wall: your eye level is at the spot you are looking at.

The vanishing point is the point where two parallel lines, if marked out on the ground and extended to the horizon, would come together. This explains the fact that railway lines appear to approach each other and finally meet in the distance – at the vanishing point.

In all my books about painting and perspective, I always use the same visual way of explaining the basic

principles; that is, as a box or cube. This may seem a little boring, but many students have told me that its simplicity makes it easy to understand. So we will use a box here, too.

In **fig. 55** I have drawn the eye level (EL) with a rectangle, above, one below, and another with its top on the eye level. I then marked a spot to the left, on the eye level; this is the vanishing point (VP). On the top rectangle, using a ruler, I drew a line from each of the four corners, all converging at the vanishing point. This gave me the two sides, the bottom and the top of the box.

I then did the same with the bottom rectangle, and so created another box. You can see the underneath of the top box and the top surface of the bottom box. Remember, you see the underneath of anything that is above the eye level, whereas you see the top of anything that is below the eye level. If you look at an object on the eye level, you will see neither the top nor the bottom. I have shown this with the third rectangle. The top left-hand and top right-hand corners are on the eye level, so the two lines drawn from these corners to the vanishing point, have to be drawn exactly over the eye level. You can't see on top of the lid, or underneath the box.

A simple experiment that will help you remember this is to take a coin, hold it horizontally in front of

Fig. 55

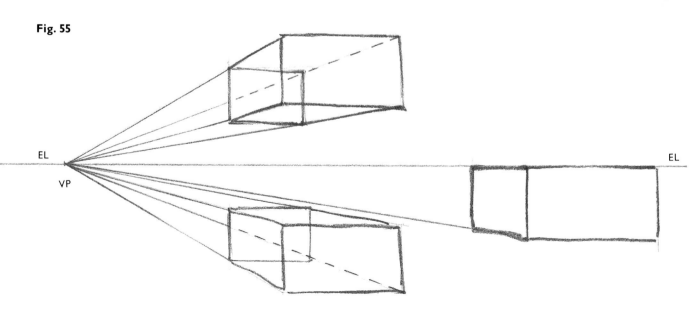

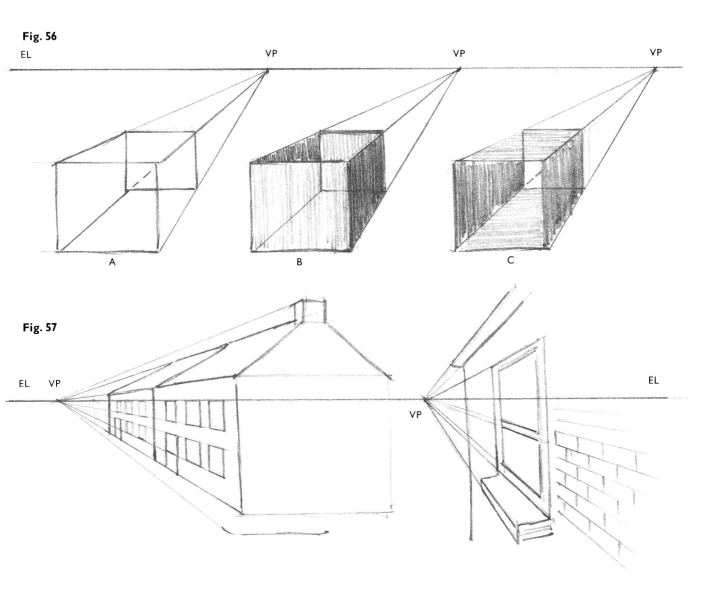

Fig. 56

EL VP VP VP

A B C

Fig. 57

EL VP VP EL

your eyes (EL). All you can see is the edge of the coin (a horizontal line). Keeping it level, move the coin up and you will see the underneath surface: it is above your eye level. Now move the coin down, past your eye level – where it appears as just a line – until you can see the top of it. The coin is now being held below your eye level.

In **fig. 56** I have shown you how I worked boxes D and E in **fig. 30**, page 29. In **fig 56**A I have shown only the construction lines without any shading. In B I have drawn the same box and shaded in some areas to give the illusion of a box without a lid. I have left the construction lines to help you understand what I have done. In C I drew the same box again, but this time I

shaded it to look like a hollow box. This lesson shows in a simple way, how three-dimensional forms can be created using perspective and dark against light.

Gradually, as you practise, you will find that you will not have to rule lines all over your drawing to get it right. Your eye will be trained **to see in perspective**, and you will need to use an eye level with a ruler only for checking purposes when you get stuck, or when something 'doesn't look right'. Once you have grasped the principle of the eye level, your drawing will improve overnight.

Finally, in **fig. 57** I have drawn a row of houses, with windows, and a close-up of a window, to show you how they are constructed in perspective.

LESSON 12

MEASURING

I'm sorry that your next lesson after perspective is another 'technical' one, but this is a natural continuation of Lesson 11, and you need some knowledge of measuring to work outdoors. I believe this is one of the most important lessons in the course.

When you look at a scene and decide what part of it you want to paint, you need to make sure that (a) you have enough space on your canvas to fit in all of your subject; (b) you do not draw the image too small for the size of your support; and, even more important, (c) the objects in your painting are the correct relative sizes. All this is done by measuring. As in perspective, practising this lesson will train your eye to measure parts of a scene automatically, but you will always have the knowledge to check what you have done, or to work on a difficult subject without problems.

When you measure, all you have to do is to establish the correct proportions of the objects in the scene in relation to each other. You measure the real-life scene first, then transfer these measurements (in scale) to your canvas. Hold your pencil at arm's length, vertically, for vertical measurement, and horizontally for horizontal measurement, with your thumb along the near edge as your measuring marker (**figs. 58** and **59**). Keep your arm at the same distance from your eye while measuring objects, or the comparative measurements will not be in proportion, so always hold your arm out straight; it is then easy to find the same position each time.

Let me take you through an example. In **fig. 60** is a photograph and in **fig. 61** opposite a drawing of the same scene to show you the main areas I measured from life. The first job is to fit the drawing on the support. Find youself a 'key measure'. This is a measure that you will use throughout the drawing. In **fig. 61**, you can see that I chose the side of the building because it was a definite line I could see and a convenient size to work with. At the real scene, I held my pencil vertically, at the top of the eaves of the house, and, moving my thumb up the pencil (**fig. 58**) until it reached the bottom of the wall, I established the key measure (KM). Keeping my thumb in the same position, I turned my hand to the horizontal position (**fig. 59**) and, starting just to the left of the house, moved my measure across the scene to check how many times the key measure would divide into the whole scene, as far as the extreme right-hand tree trunk (10 KMs). With just my key measure and the knowledge that it goes across that scene ten times, I

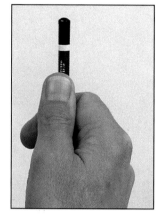 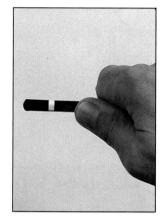

Fig. 58 **Fig. 59**

Fig. 60

could fit my picture exactly on to any size of support.

First draw a line to represent the side of the building where you think it should go on your support. Then, using your pencil and thumb, measure on your canvas the length of your line, or key measure, and check whether you can get ten key measures across your support. If you can get less, your key measure is too big for your support size, so draw your key measure (the side of the house) smaller, then try again until your key measure fits ten times across your support. You can see that the size of the subject or size of support doesn't matter; it is the scale at which you draw it that changes. Now you have established the correct scale.

key
measure

$4\frac{1}{2}$ KM

2 KM

3 KM

2 KM

1 KM

Fig. 61

Next, measure the scene to check how many times your key measure goes vertically up to the bottom of the house, and mark the spot on your support; that is where the base of your key measure (side of the house) starts. In the same way, check the position of your key measure from the left side of the picture.

Now you can measure the relative positions and sizes of objects in the scene, using the key measure. For example, in **fig. 61** the gate on the left is 2 KM long, the height of the wall down by the water is 1 KM, the two large trees are $4\frac{1}{2}$ KM wide, and so on. If you are painting a complicated subject, you can use more than one key measure. For instance, in this scene you could use the height of a window on the house for

smaller measurements.

Read through these instructions carefully and practise measuring objects in your room. When you are painting, your measurements need not be too precise; you can estimate that a wall is about two and a bit times the key measure, or a window goes into the house wall almost three times. It will soon become second nature, so do keep practising.

SKETCHING

A sketch is the beginning. Any creative work, in any medium, is started with a sketch. The sketch can be in our mind's eye or on paper. It is an idea that we put on to paper in order to remember it as well as to record it forever.

When you are out looking for a scene to paint, the first positive step towards creating your painting is made when you look at the landscape and decide, in your mind, which particular section you want to put into your painting – for instance, start at the tree on the left down as far as the farmhouse, let the dark area of shadow on the right go out of your picture, and so on. You sketch the scene in your mind's eye then, when you are happy with that, you paint your picture.

While mowing the lawn or doing the shopping, you could have a flash of inspiration, an idea for a painting, but you can't carry it in your head. At the first opportunity you sketch the idea on paper. So we use a sketch for storing ideas and information.

We also use a sketch for gathering information – perhaps this is its most important role, especially for less experienced students. If you were outside and you wanted to paint the scene in front of you, but for all sorts of reasons you couldn't paint it at that time, you would make a sketch of the scene and paint it at home. You would have to put as much information as possible into your sketch because when you used it to work from later, you would not be able to check any

detail with the real-life scene. You would have only your memory to help you.

One of the greatest assets you acquire when sketching from nature is knowledge of the subject. Because you can't take the subject home with you, you are forced to search for details, to see things correctly and not to let things just happen on your canvas because you don't understand them. Let your eye search for the way objects are made, the way they are positioned, how they grow, their colour and tone against other objects. What you have to do, if you haven't guessed already, is **to observe**. I discussed this in Lesson 10 and now you can now see how important it is. One of the best ways to sharpen your powers of observation is to practise half-hour painting exercises, which are covered in Lesson 15.

A few years ago, when I was writing my book 'Learn to Sketch', I gave a great deal of thought to the practical side of sketching. I broke down the sketch into three distinct types:

Information sketch A drawing or painting made solely to record information or detail, which can be used later at home or in the studio.

Atmosphere sketch A drawing or painting worked specifically to instil atmosphere and mood into the finished result. It can be used for atmosphere and mood information, or alternatively as inspiration for another painting.

Enjoyment sketch A drawing or painting worked on location, for pure pleasure.

The best medium for recording detail in a sketch is pencil on cartridge drawing paper. Sketchbooks are usually filled with this type of drawing paper, so if I want to sketch something in great detail, I usually work in pencil in a sketchbook. Alternatively, you can paint in oil and draw some detail notes with a pencil in your sketchbook.

However, I feel that oil is the best medium for capturing mood and atmosphere. The sketch in **fig. 62** is an atmosphere sketch, painted very freely. I painted this late one winter afternoon on the beach, looking towards the River Exe estuary. The sun was very low, a heavy shower had just passed over, and the sea was very still. Although I could see some detail in the fields above the cliffs, I didn't attempt to put it in. I just painted straight in, without drawing first, working on primed hardboard over a Yellow Ochre wash. The

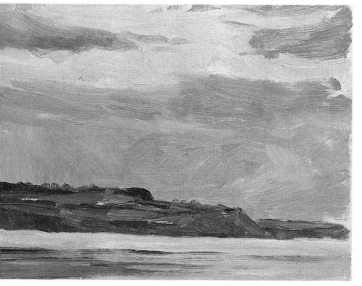

Fig. 62 Atmosphere sketch, *Towards Exmouth*. Primed hardboard, 15 × 20 cm (6 × 8 in)

sketch took about 20 minutes to complete.

Incidentally, I give my painting time for some of the work in this course, not because I want to say how quick or slow I am at painting, but to give you a starting point. For instance, if you didn't know how long I took to do the seascape sketch (**fig. 62**), you might think it should take three hours; and, if you are a beginner, why not three hours? But above all, if you did work a small sketch such as the one in **fig. 62** over a three-hour period, you would have missed the point about sketching.

When I started to paint this sketch, the sky was changing its mood and shape every few minutes. I had only about an hour before the sun went down, so I couldn't have taken longer than an hour at the most. And most important of all, if a small sketch like this were painted over a period of three hours, then it would have been over-worked; the colours could have become muddy and the freshness of the scene been lost. On the other hand, if I had taken three hours to do the painting and you thought, because of its size, it should take you only about half an hour, then you would be working with a tremendous handicap, because you would not be able to get three hours' work into half an hour.

Apart from the above comments, your speed of painting is not important. Some artists paint very fast, others very slowly and the majority somewhere in between. If you naturally paint quickly, this is a tremendous bonus when working outside, especially when sketching.

The sketch in **fig. 63** is a pure enjoyment sketch. One morning I passed this group of trees at the end of a field of cabbages. Some had been cut, revealing the red Devon soil; there were some autumn leaves still on the trees with the sun on them – it was breathtaking. Usually, when you see something that inspires you as much as this you haven't got your sketching gear – and I hadn't! Four days later the weather was just the same and, as I had to pass this spot, I made sure that I took my equipment and had enough time to stop and sketch. Unfortunately, more cabbages had been cut, which showed far more earth, but the scene still inspired me.

I took about 25 minutes to paint this sketch, working on primed hardboard over a Yellow Ochre wash. I drew in first with a turpsy wash of Cobalt Blue and Crimson Alizarin, starting with the tree trunks, the hedge, then the path across the field. Notice how freely the trees are painted. And have you also noticed that I didn't paint in the sky behind the trees? It is still the original Yellow Ochre wash. I started to put in the blue for the sky and then decided that the sketch looked good with the sky reflecting the colour of the ground. I am happy with the sketch and, most important, I

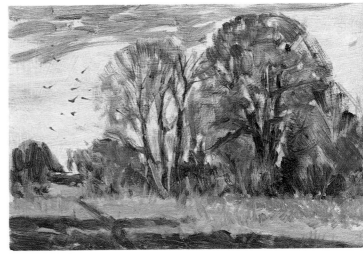

Fig. 63 Enjoyment sketch, *Near Starcross*. Primed hardboard, 15 × 20 cm (6 × 8 in)

enjoyed the experience of doing it.

The first sketch in the book, **fig. 3**, page 8, is also an enjoyment sketch.

I am often asked: When is a sketch finished? The answer lies with you – when you have gathered enough information from which to work at a later stage, without the model (the scene). A sketch can therefore appear over-worked for some artists and understated for others. I am asked the same question about a painting: when is it finished? This again depends on the artist. Some like to put a great deal of detail into their work; others try to paint a picture with as few brush strokes as possible. These are the two extremes. To some people the first would look finished, and the second one only just started, but each would be accepted as finished by its creator.

As a general guide, if you reach a stage in a painting where you feel you can't put any more work into it in order to convey what you set out to do, then it is finished. As another guideline, when you are looking for things to do in the painting, rather than knowing what you still have to do, that is the time to stop. When you think you have finished, take a break – for ten minutes or overnight – and then look at your painting. If nothing worries you, then stop.

The most intriguing question I am asked by students is: When is a sketch a painting, and when is a painting a sketch? Where do we draw the line? I have very definite feelings about this. All sketches are paintings. Any creative piece of art, whether it has taken two minutes or two years to do, is a painting. The only dividing line between a painting and a sketch is that the latter was done specifically to collect information. But then, if you went out to do a painting, your painting would have gathered information; therefore it is a sketch.

Some paintings are referred to as sketches, some as

studies and others as paintings, but whatever the reason for their being created, they are all creative works of art in their own right, and are therefore paintings. In fact, some of the Old Masters' sketches are preferred to their finished paintings. When we refer to a sketch, it doesn't mean that it has to be small. A sketch can be any size. Some artists paint their sketches the same size as their finished paintings. In the end, only the artist knows whether he has produced a 'genuine sketch' or a painting.

Don't ever hesitate to put a small sketch into an exhibition; it is just as important as a large painting. If it is well framed it can look like a jewel among larger more finished paintings.

The photograph in **fig. 64** is one I took of Salisbury Cathedral, and I have used this to give you an example of sketching. The day was a little overcast, but at times the sun came out and made some fabulous sunlit and dark shadow areas over the countryside. I decided to make a pencil sketch (**fig. 65**) for information, and an oil sketch for atmosphere (**fig. 67**). I hadn't been there long before the first stab of sunlight struck the middle distance. The contrasting dark shadow areas and the dark silhouette of the Cathedral were very inspiring. I decided there and then that this would be the mood in which I would paint the sketch. With this type of day this scene would be created quite a few times, so each time the sun came out over the middle distance I would make mental notes. For this demonstration I did the oil sketch at home, from the pencil sketch.

First, I drew the scene on cartridge paper with a 2B pencil (**fig. 65**), purposely taking in an extensive view. This meant that I would have enough information to work a larger scene at a later date if I wished.

Fig. 64

Then I painted the sketch. I worked on oil sketching paper, smooth, over a wash of Yellow Ochre mixed with a little Crimson Alizarin. I drew the scene (Stage 1, **fig. 66**) with a turpsy wash of Cobalt Blue and Crimson Alizarin with my No. 1 brush, and filled in some tonal areas as I drew in. In the finished stage (**fig. 67**) I used my No. 4 brush for the rest of the painting, starting at the sky and working down. I didn't paint over the Cathedral because the paint would have been wet and the darker paint for the Cathedral would have picked up the lighter colour underneath. Notice how I let some of the Yellow Ochre wash come through in the sunlit area; this helped to unify the colour of the sunlit middle distance. I also let some of the wash show through on the foreground housing estate.

Fig. 65 Pencil sketch on cartridge paper, 10 × 25 cm (4 × 10 in)

Fig. 66 (above) Stage 1

Fig. 67 (below) Finished stage. Oil sketching paper, fine grain, 15 × 20 cm (6 × 8 in)

SKETCHING EXERCISES

With oil, you usually work from dark to light, using thin paint for the dark areas, progressively thicker paint for the lighter areas, and at the end, very thick paint for highlights. However, during a painting there are times when you reverse this practice. This is often the case when working outside, and especially when sketching a moving scene: for instance, a harbour scene, a horse-racing event, a regatta – scenes where you are having almost to build and re-build a painting as it happens. (I don't suggest you tackle this type of scene yet, but one day you will.)

I am often asked by students which area to paint first: for instance, the background or the object. There are no hard-and-fast rules about this. I find that it is more practical to paint a lighter colour up to a dark shape. Because the dark paint is usually thinner than the lighter colour you do not pick up the dark paint very much when you touch it with your lighter paint. Try it, and see how you feel. We all have our own way of painting and this is what gives paintings their individuality. As you copy the exercises and gain experience, you will find certain things happen naturally to your painting; your own style will develop. Don't hold it back, but don't force it.

Remember, you can always wipe paint off your support with a piece of rag or your palette knife if you want to change an area and the paint is too wet or thick to paint over comfortably. But when you do want to paint over wet paint without disturbing it, you must mix plenty of Alkyd Medium with the paint to make it very 'juicy' (liquid). When you paint, do not put much pressure on the brush stroke or you will pull up the paint underneath.

Most likely, in the exercises so far you have

Fig. 68 This sketch of Venice shows how simply you can paint complicated buildings. Primed hardboard, 15 × 20 cm (6 × 8 in)

experienced some of these problems. Good! That means you have been working hard.

I have included the sketch in **fig. 68** to show how simply you can paint complicated buildings and still give the impression of realism.

River Teign Estuary

The scene in **fig. 72** was painted late one afternoon, when the tide was out and the sun was low, to my left. All the buildings and hills had become soft silhouettes.

In Stage 1 (**fig. 69**), draw the main areas with a 2B pencil on a white ground then, using your No. 4 brush and a turpsy mix of Cobalt Blue and Crimson Alizarin, paint in the tonal values.

In Stage 2 (**fig. 70**), start with the sky, using your No. 4 brush and a mix of Titanium White, Cadmium Yellow and a touch of Crimson Alizarin. Change to a mix of Titanium White, Cobalt Blue, Crimson Alizarin and a little Cadmium Yellow, and paint in the hills. With your No. 1 brush and the same mix but darker (less Titanium White), add the buildings and jetty.

In the finished stage (**fig. 72**), start with the dark tree and dark mud using the colours that you used for the buildings, but not much Titanium White. Then, using the same colours with more Titanium White and more Cadmium Yellow added, paint in the foreground mud with your No. 4 brush. Leave small areas of the blue under-painting showing to give the illusion of light catching the wet mud. Paint in the water, adding more Cadmium Yellow to your mix as you work to the right, where the sun is catching the river. With your rigger brush, paint in the masts on the boats and finally, with your No. 1 brush, add the highlights on the left-hand side of each boat.

In this and the following exercises I have not stated all the colours I used because, by now, you should be able to choose and mix your own.

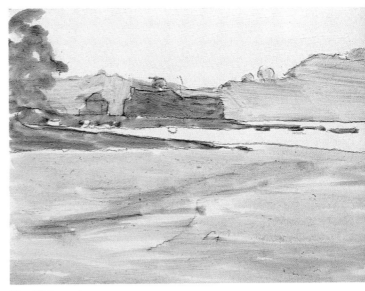

Fig. 69 Stage 1

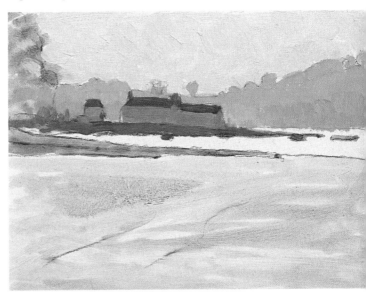

Fig. 70 Stage 2

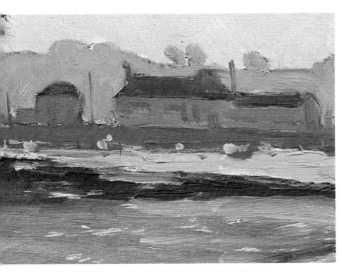

Fig. 71 Detail from the finished stage, **fig. 72**

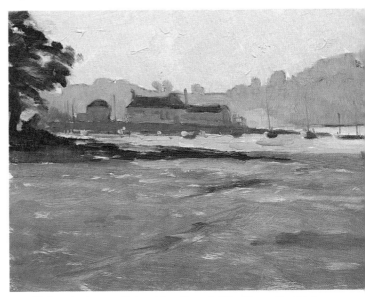

Fig. 72 Finished stage. Primed hardboard, 15 × 20 cm (6 × 8 in)

59

Norfolk Broads

I have always enjoyed painting on the Norfolk Broads; perhaps because there's plenty of water. As in the previous sketch, start Stage 1 (**fig. 73**) by drawing in the main areas with a 2B pencil on a white ground. Remember, if you want to draw in with your brush without first drawing with a pencil, that's fine. In fact, for most of my **sketches** I don't draw first with a pencil, and I start painting some without any drawing at all. Naturally, this depends on the subject and the time available (if you were sketching a sunset, by the time you had drawn it the sky could have changed completely). But back to the Broads.

With a turpsy wash of Cobalt Blue and a little Crimson Alizarin, paint in the tonal areas, using your No. 1 brush.

In Stage 2 (**fig. 74**), paint the sky, using your No. 4 brush with different colours mixed from Titanium White, Yellow Ochre, Crimson Alizarin and Cobalt Blue. For the 'blue' sky use Cobalt Blue and Titanium White only. Now use your No. 1 brush and the same colours as for the sky with a little Titanium White added, and paint in the background buildings. Mix in a touch of Cadmium Yellow and more Titanium White, and paint the fields and trees.

For the finished stage (**fig. 76**), use your No. 4 brush to paint in the bank of the river and continue to paint the shadow colour into the water and over the under-painting of the reflections. Leave some small areas of under-painting showing, to give a suggestion of movement on the water.

Next, paint in the boat with your No. 1 brush. Apart from the cabin side, which is a warm brown colour, use the same colours as for the sky. Now for the exciting part of the water. With your No. 4 brush and the sky colour, using short horizontal brush strokes, paint the light-coloured areas of the water. Paint freely, letting the brush strokes overlap and the colours mix in places. Put in the man and the main mast with your No. 1 brush; then, using your rigger brush, paint in the other masts and rigging. Don't forget the little touch of yellow in the water – the man's reflection.

Fig. 76 (right) Finished stage. Primed hardboard, 25 × 30 cm (10 × 12 in)

Fig. 75 (below) Detail from the finished stage, **fig. 76**

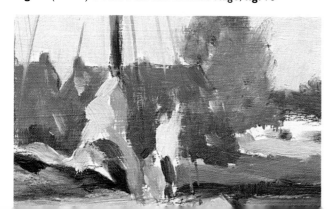

Fig. 73 Stage 1

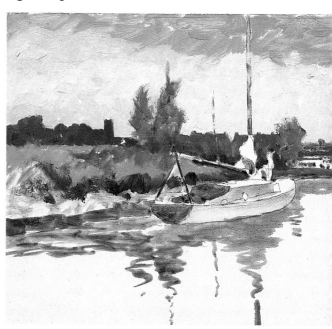

Fig. 74 (above) Stage 2

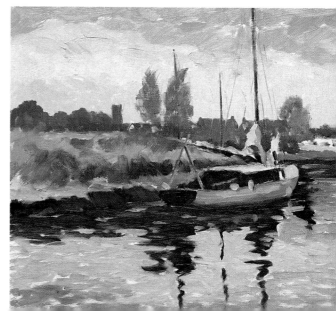

House by the canal

This is a familiar spot in **fig. 80**. I used to pass by frequently, and have seen this particular canal in many moods. I painted the scene on an early autumn morning, when the sun was very low and catching the side of the red-brick house.

On a Raw Sienna wash ground, start Stage 1 (**fig. 77**) by drawing with a 2B pencil, or simply draw straight in with a turpsy wash of Cobalt Blue and Crimson Alizarin, using your No. 6 sable brush, and your rigger for the smaller branches of the trees. Notice how freely I have drawn the trees and canal bank. Whatever you do, don't labour this; don't try to copy all my brush strokes – it's impossible. If your brush draws branches different to mine, leave them.

In Stage 2 (**fig. 78**), where you start to put in colour, still work very freely and let some of the colours in the background overlap and merge together. This helps to give a feeling of depth around the trees. Notice that I put no detail in the roof or the shadow side of this house, nor did I paint over the main tree trunk. This made it easier to paint the trunk in the following stage.

Paint in the trunks of the main trees with your No. 1 brush, then use your No. 4 brush to work the shadow part of the bank (finished stage, **fig. 80**). With the same colour continue down into the reflection areas of the water, but do this with downward brush strokes. Then paint in the lighter areas of the water, but do this with horizontal strokes. Then paint in the lighter areas of the bank to the right of the main tree. Now take your No. 1 brush and paint in the reflections of the house and sky. Notice how I have let a few brush strokes wander into the reflection areas of the water. This helps to create the illusion of water and to give it slight movement. With your rigger brush paint in the smaller branches on the trees. Notice how I painted some sky back over the trees on the right. This was done with quick brush strokes but it gave more light to the trees. If you look closely you will see quite a lot of the Raw Sienna under-painting showing through, especially around the trees and canal bank (**fig. 79**), and that the painting is done very freely.

Fig. 80 (right) Finished stage. Oil sketching paper, fine grain, 25 × 30 cm (10 × 12 in)

Fig. 79 (below) Detail from the finished stage, **fig. 80**

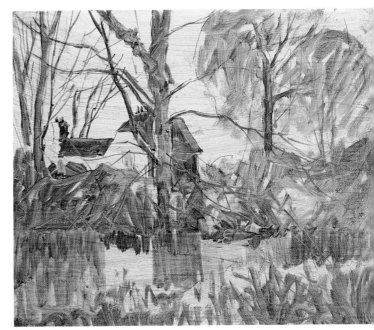

Fig. 77 Stage I

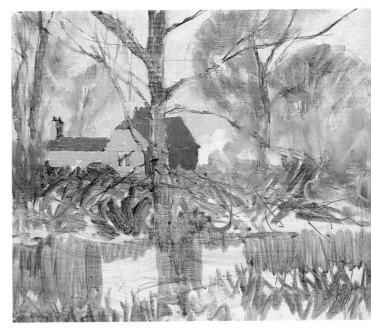

Fig. 78 (above) Stage 2

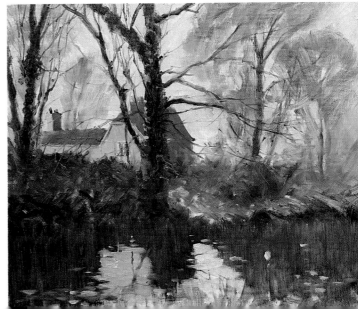

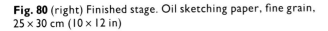

Fig. 81 Stage I

Distant trees

The painting in **fig. 83** is a typical landscape scene from my part of the country. Sheep look strange in a ploughed field, but that's how I saw them; notice that they are the same colour as the field.

Start Stage 1 (**fig. 81**) on a Raw Sienna wash ground and, as usual, draw in the main areas with a pencil or brush – use Cobalt Blue and a little Crimson Alizarin, and your No. 1 brush.

Now paint the sky and hills down to the middle distance trees (Stage 2, **fig. 82**). With your No. 4 brush very dry (very little paint) put in the trees, using a brush stroke called scumbling – working a thin layer of paint over another so that in places the under-layer shows through, creating a broken, uneven effect. The way to do it is simply to scrub the brush over the surface in all directions as though you had no regard for the bristles. Practise this brush stroke; it is an important one and is used frequently. You may find that you have been using it already. Now paint in the two green fields and the ploughed field.

In the final stage (**fig. 83**), scumble the main trees over the background, then use your rigger to paint some branches over your scumbling. Finally, paint in the foreground field (notice the direction of the brush strokes) and put in the sheep.

Fig. 82 Stage 2

Fig. 83 Finished stage. Oil sketching paper, fine grain, 20 × 15 cm (8 × 6 in)

In the olive grove

When I am sketching people and I know that they will stay reasonably still for a while, I prefer to draw them in pencil first, then paint them in. So draw them first in pencil on a Raw Sienna ground (Stage 1, **fig. 84**).

Start Stage 2 (**fig. 85**) by painting in the flesh areas, using a mix of Titanium White, Cadmium Red and Cadmium Yellow, then the complete figures, and finally the main tree trunk – use your No. 1 brush for all the figure work. You now have the two people established in your painting.

In the finished stage (**fig. 86**) notice how I have left much of the Raw Sienna background showing unpainted, which helps to give a sunlight effect. Don't labour any features – you are not painting a portrait – only suggest them. If they look good, that's fine; if they don't, it doesn't matter. You are trying to portray two people sitting under a tree in sunlight; the faces are only a detail, and in this type of sketch you don't give them much attention.

Fig. 84 Stage 1

Fig. 85 Stage 2

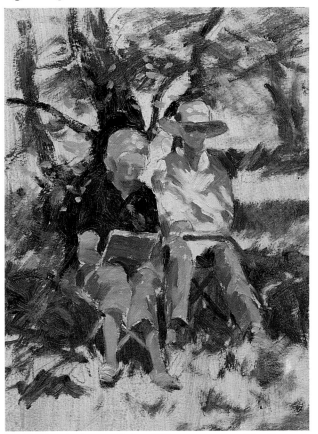

Fig. 86 Finished stage. Primed Whatman paper, 20 × 15 cm (8 × 6 in)

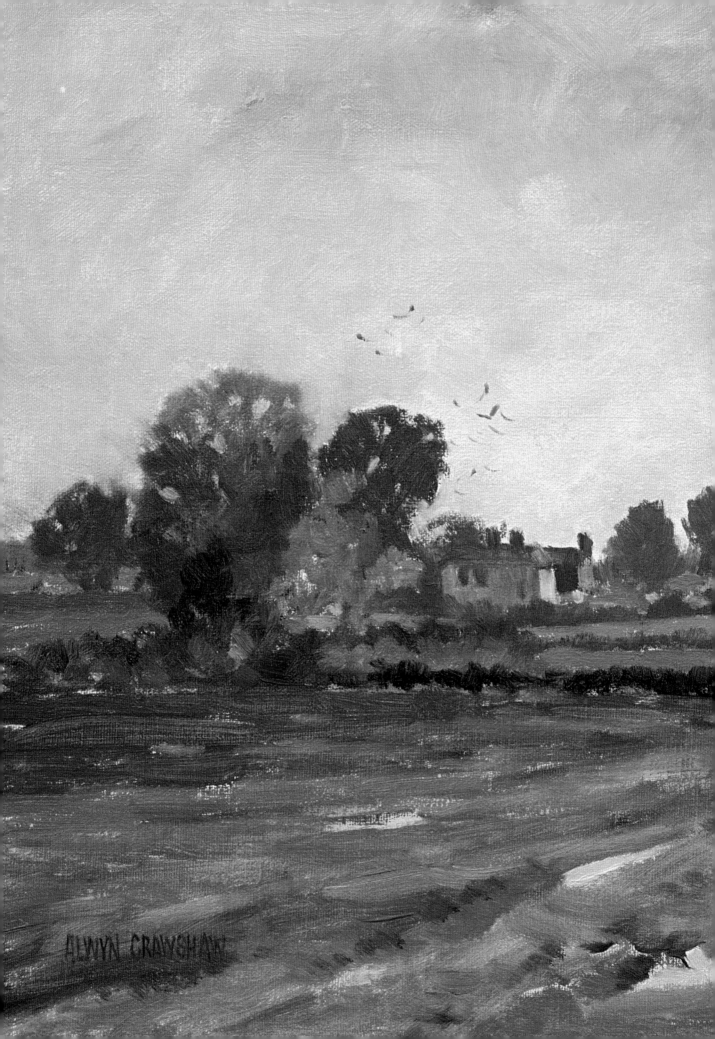

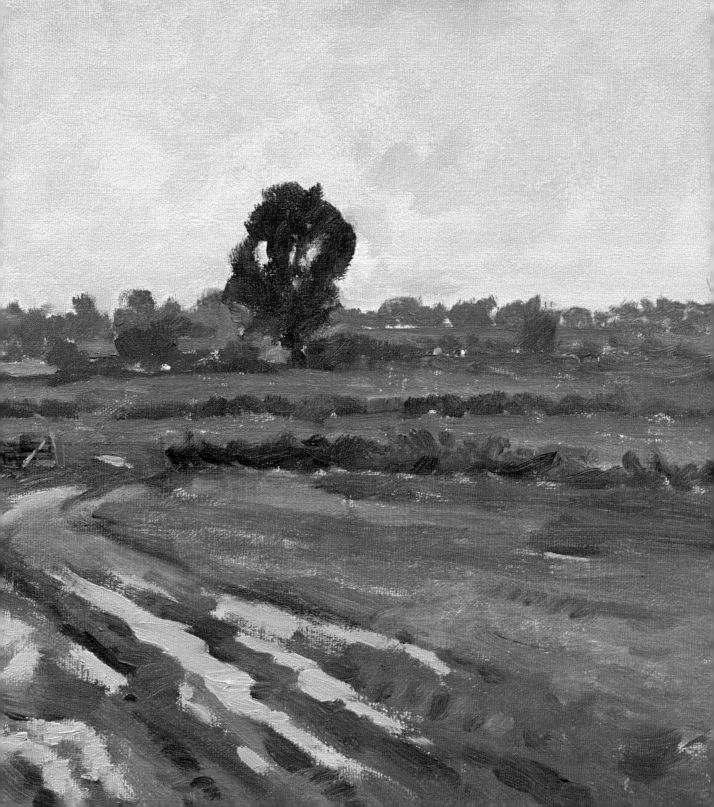

Part Four
SIMPLIFYING WHAT YOU SEE

SIMPLIFYING WHAT YOU SEE

Fig. 87

When you are painting a tree, you know it bears thousands of leaves but, naturally, you wouldn't think of trying to paint each individual leaf. Similarly, you wouldn't try to paint every cabbage in a cabbage field. So you have to simplify the tree and the field, and paint an impression of them. This applies to all subjects and all styles of painting; even a very detailed painting of a tree does not show every leaf.

The illusion of a field or a tree in the middle distance can be created by just a couple of brush strokes. But simplifying the subject does not mean making the painting easy. It means observing the subject carefully and finding a way to create it on canvas. Sometimes it is easy, such as when you are painting a field, but at other times you have to think more carefully.

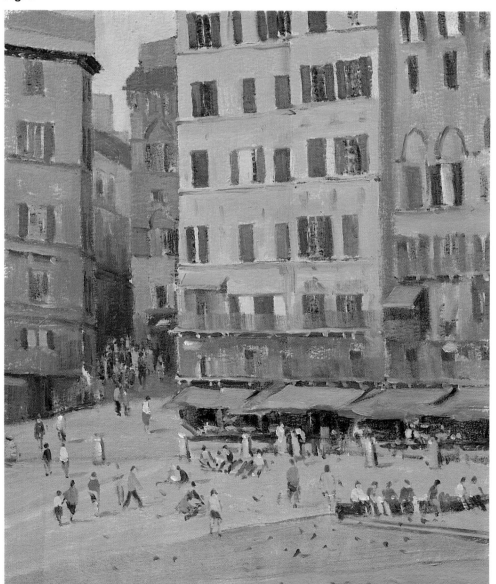

Fig. 88 (left) *Sienna*. Compare the buildings in the photograph, **fig. 87**, with this illustration to see how I have simplified them. Primed Whatman paper, 30 × 25 cm (12 × 10 in)

Fig. 90 (opposite, below) *River Otter, Devon*. Look at the photograph in **fig. 89** and then notice how I have simplified the water and trees in this painting. Primed Whatman paper, 25 × 30 cm (10 × 12 in)

June and I always include some half-hour exercises on our painting courses, where students paint the subject in front of them in half an hour. It is one of the best ways to learn how to simplify. Most students think it is impossible, until they try it, and they are invariably surprised and excited by the result. Some of them paint little masterpieces.

The time limit teaches you discipline. It forces you to look for the important shapes and forms; to avoid fiddling with a small brush; to have all your materials clean and ready before you start; and to concentrate all your attention on your subject.

First, you have to observe your subject, and you should have been practising this already (Lesson 10). Look at the subject constructively, relating one object to another – its size, shape, colour and so on. Because you can paint a half-hour exercise only by observing, this lesson will help you to develop your skill.

Half-hour exercises make invaluable practice. So choose any exercise in the book and do it again in half an hour. When you have done that try some outdoors. When June and I made a trip to Europe a few years ago, I did each painting in half an hour and I gained a great deal of experience from it.

On my courses, students work outdoors with me at their side to explain how to simplify the scene. On the following pages my photographs and paintings of the same subject are reproduced side by side, so that you can imagine we are outside together and I am showing you how I simplified the scene.

You should enjoy working these exercises, as I enjoyed painting them for you – and they will teach you a great deal.

Fig. 89

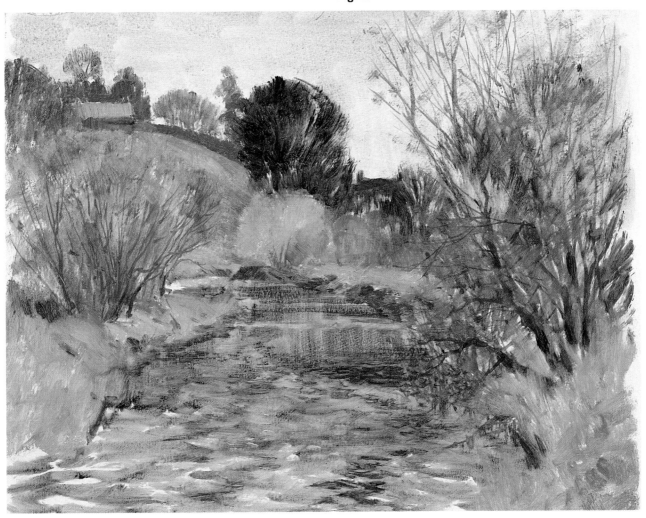

SIMPLIFYING LANDSCAPE

Fig. 91

I have decided to start with a panoramic view of a landscape (**fig. 91**) because the amount of detail and sheer size of the subject can be awesome for a student. As you should know by now, before beginning to paint a scene such as this you must first observe it. As you look at it, shapes will become familiar. You will pick out roads, tracks, outbuildings; patterns that are important for your painting, such as dark and light areas; how, for instance, the cypress trees in **fig. 91** are prominent (dark) against the background.

It doesn't matter how long it takes to prepare your mind by observation; it could be five minutes or twenty, depending on the subject or the student, but it must be done. In almost any painting there are some areas where it is hard to decide what was painted; they appear to be just a few daubs of colour on an undefined background. These are some of the most important parts of a painting; they suggest rather than explain to the onlooker what is happening. I call these 'nothingness' areas. There is an example in this painting, and I have shown it the size that I painted it in **fig. 92**. Out of context it means nothing, yet in the painting it suggests a lot of trees, shadows and whatever you like to imagine. Look back at the canal sketch on page 61 and you will see that the left-hand hedge and water are 'nothingness'; also on the right-

hand side, in the trees, where it suggests undergrowth, brambles, branches, twigs etc. (**fig. 79**). In fact, looking at the real scene it was difficult to make out 'what was going on', even with intense observation. These 'nothingness' areas are valuable – they give great depth to a painting.

I started to paint Stage 1 (**fig. 93**) by drawing the main shapes in pencil on oil sketching paper, over a Yellow Ochre and Crimson Alizarin wash. Then I drew in with a turpsy wash of Cobalt Blue and Crimson Alizarin, using my No. 1 brush. Notice how blue I painted the distance, which makes it recede when the warm colours of the foreground are painted. Remember, cool (bluish) colours recede and warm (reddish) colours come forward; therefore, in a

Fig. 92 Detail from the finished stage, **fig. 94**

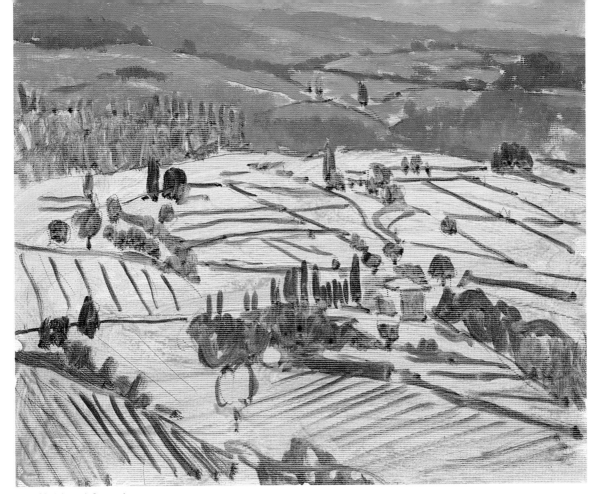

Fig. 93 (above) Stage 1

Fig. 94 (below) Finished stage. Oil sketching paper, fine grain 25 × 30 cm (10 × 12 in)

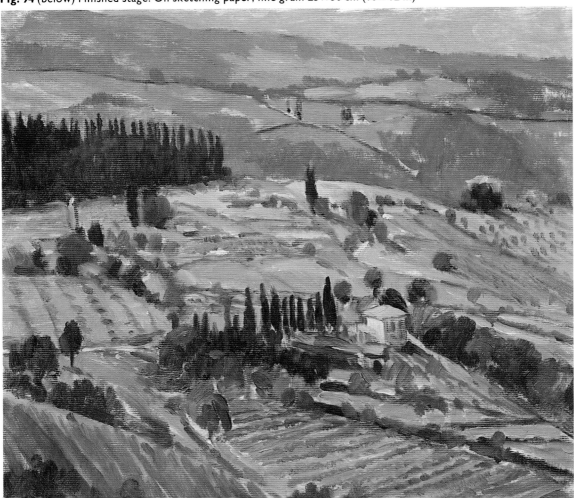

landscape make the distance cool, the middle distance warmer, and the foreground warmer still, to achieve recession in your picture. Notice also how I simplified the forests and fields in the distance in Stage 1 (**fig. 93**); I didn't put any more work on them in the finished stage (**fig. 94**).

Fig. 95 shows a photograph I took when I was in the Channel Islands. The field in front of the trees was full of pale mauve flowers (phacelia), which are ploughed back into the soil as a fertilizer. I was inspired by the dark silhouette of the trees with the sunlit fields and houses behind them.

Working on primed hardboard, which I coloured with a Yellow Ochre and Crimson Alizarin wash, I drew in the main areas of the scene in pencil. Normally, I wouldn't draw something like this with a pencil first, but as I had to do it twice (for Stages 1 and 2) I felt that would make it easier to get the two stages proportionally correct. If you want to go straight ahead with your No. 1 brush to draw in – and this applies to any lesson – do so; it shows that you are beginning to gain confidence.

After painting in the trees, I used my No. 6 brush and added Yellow Ochre to the turpsy mix and very freely suggested the foliage of the trees (**fig. 97**). I painted the sky thinly because later I had to paint the finished foliage of the trees over the top of it and I didn't want to work over thick wet paint.

Next, I painted in the distant trees; notice that they are cooler than the foreground trees. I simplified the buildings by not attempting to put any detail in them, except for a simple brush stroke to represent windows. In real life, at that distance I could see quite a lot of form and shape in the houses, but had I put it all in it would have 'jumped out' of the picture.

I painted over the foliage of the trees again with my No. 6 brush, using thicker paint mixed from Cobalt Blue, Cadmium Yellow and a little Crimson Alizarin (**fig. 98**). This was done very freely, with the brush strokes overlapping each other in places. Then, with my No. 6 sable brush and the same colour, I suggested clusters of leaves on the edges of the solid mass. Finally, with the same brush but darker paint, I worked over the tree trunks and added some smaller branches in the foliage.

The flowers were worked very simply with my No. 4 brush. If I had used a small brush, say my rigger, I would have had to paint almost every bloom, which would have looked too detailed, and out of character with the rest of the painting.

It is important to note that this and all the other exercises in the book, unless otherwise stated, are painted in one sitting. This means that the paint has always been wet; I have not waited for any area to dry before carrying on with the painting.

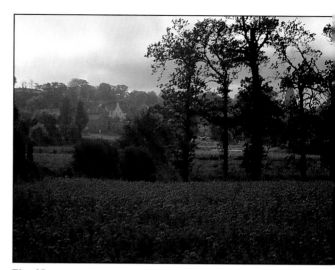

Fig. 95

Fig. 96 Detail of the finished stage, **fig. 98**

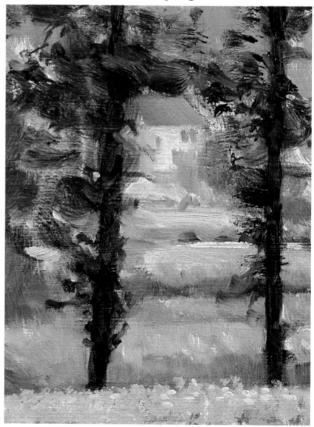

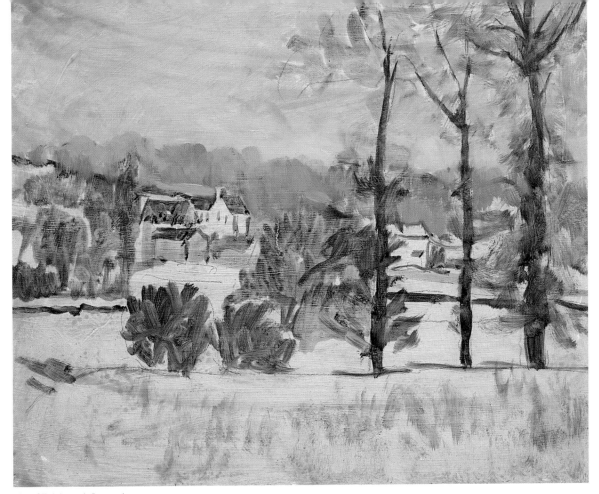

Fig. 97 (above) Stage 1

Fig. 98 (below) Finished stage. Primed hardboard, 25 × 30 cm (10 × 12 in)

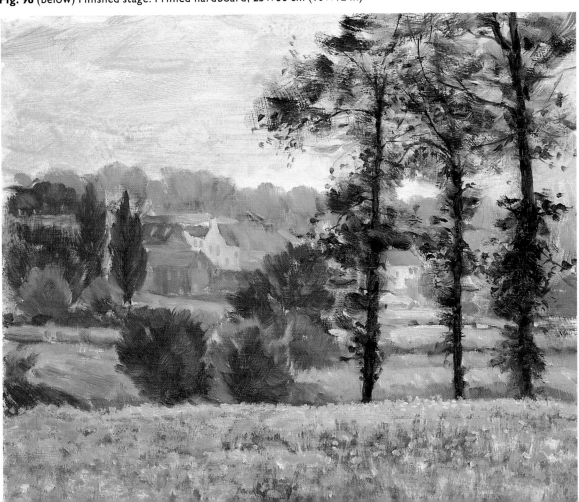

71

SIMPLIFYING FOREGROUND

Never try to make foreground too detailed: the more detailed it is, the more detail you have to put into the rest of the picture. Because you can see the detail, don't fall into the trap of trying to paint it – something we all do at times.

What do we mean by detail? If you had a pebble from the beach, drew it and painted it, and added all the cracks and different colours that you could see, perhaps even some wet sand stuck to its surface, that would be detail. If you painted a beach with that pebble on it, then the pebble would be detail, but you would not paint the detail on the pebble. If you painted a scene that included the beach, then the beach would be a detail of the scene; you would not paint the individual pebbles. Think what would happen if you painted the detail on the pebble, all the pebbles on the beach, and this beach was in the middle distance of a scene. Just imagine the amount of detail you would have to paint in the foreground.

Decide how much detail you are capable of painting, and keep that ability for the foreground, or the centre of interest, then the detail in your painting will recede, which is the way it should be.

You need only enough detail to tell the story in a particular painting. Remember, just because you can see more in the foreground doesn't mean that you have to paint more.

Omitting detail does not mean omitting shape or form. Look at the muddy track in **figs. 99, 102** and **103**. There is form and shape created by brush strokes of light against dark to show the wheel tracks of farm vehicles, but there is no detail within the muddy tracks. So the detail has been used only for this purpose, not to show individual lumps of earth with insects on them, stones and grass squashed into the mud or an old piece of barbed wire. This would have overdone the detail for this particular picture. It would have been detail within detail. My aim was to create an impression of a muddy path, not a study of what you can find on a muddy path.

The foreground may be subordinate to the rest of the painting, when it would need to be painted very simply, with only a hint of detail. Look at **fig. 158** on page 100. The foreground is only suggested, without detail, because the boats are the most important part of the painting.

Fig. 99 (left)

Fig. 100 (below, left) Photograph of foreground

Fig. 101 (below) Simplified foreground painted

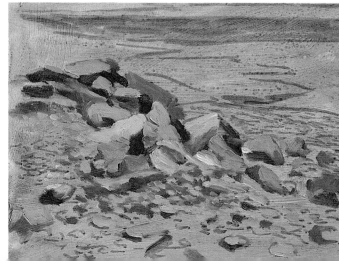

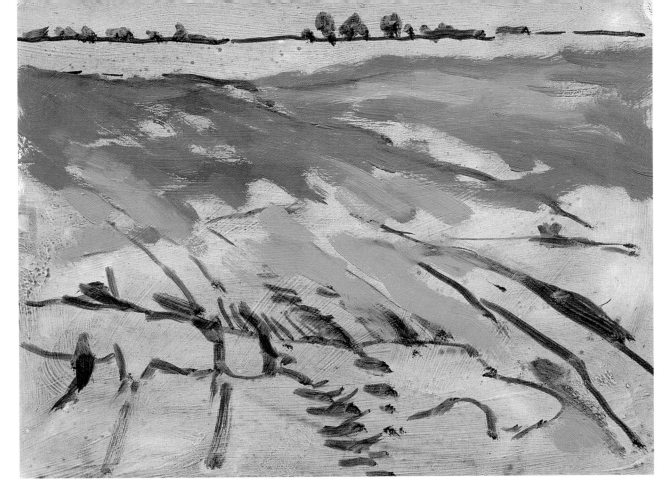

Fig. 102 (above) Stage 1

Fig. 103 (below) Finished stage. Primed hardboard, 15 × 20 cm (6 × 8 in)

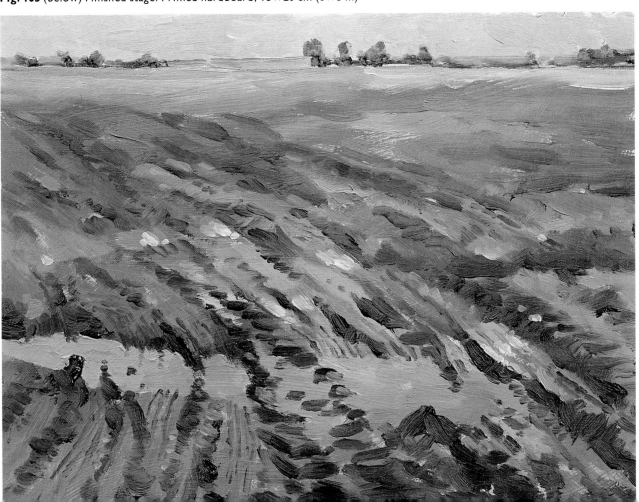

SIMPLIFYING TREES

Trees are a feature of most landscapes so it is important to practise drawing and painting them until they become a familiar subject. Go out and draw them with a pencil first, so that you get used to the way they grow. When you are waiting for a bus or train, there are usually some trees in sight. Look at them, observe them, let your painting brain understand them. If you have a sketchbook with you, sketch them. Choose a species that you like and then study each example you find, draw it, and then paint it.

Start by working from a distance, say two hundred yards (**fig. 108**) to get to know the shape and form of the tree, and its natural habitat. This is important because, when you create a picture at home from imagination, no matter how much careful work you put into it, if you painted a willow tree on the top of a hill it would look wrong. Willows like water, and are usually found in low-lying areas where there is always plenty of moisture.

Progress by working closer to your tree so that you can see more detail and form. Then work very close, and draw the branches growing from the trunk; the leaves in summer; the bare branches in winter. Then do it again, with your paints. Once you have mastered your favourite tree, other species will be easy to paint. Apart from their particular shape or colouring, they are all pretty much the same from the painter's point of view.

When you paint a tree in summer, make sure you show some sky and some branches through the foliage so that the tree does not look solid, like a lump of plasticene. If you are painting a tree from nature and it doesn't show any 'holes' in its foliage from your painting position, it is a good idea to create some; your tree will look more natural. For the scene in **fig. 104** I used a No. 6 sable and my rigger brush for all the branches on the trees (**fig. 107**). Notice how I gave the illusion of leaves on the two left-hand trees by using dry brush strokes with my No. 4 brush. I didn't try to paint all the leaves. On the densely foliaged oak tree, I used thick paint and worked it with my No. 2 brush. For the green on all the trees I used mixtures of Cobalt Blue, Cadmium Yellow, Yellow Ochre, Crimson Alizarin and of course, Titanium White.

In oil painting, the sky colour is very often painted over the foliage to create shape and form within the tree (**fig. 108**). Look at **fig. 53** on page 48, where the sky and the background field showing through the large trees were painted over the already painted trees.

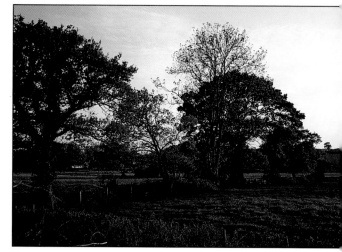

Fig. 104

Fig. 105 Detail from the finished stage, **fig. 108**

Fig. 106 Detail from the finished stage, **fig. 108**

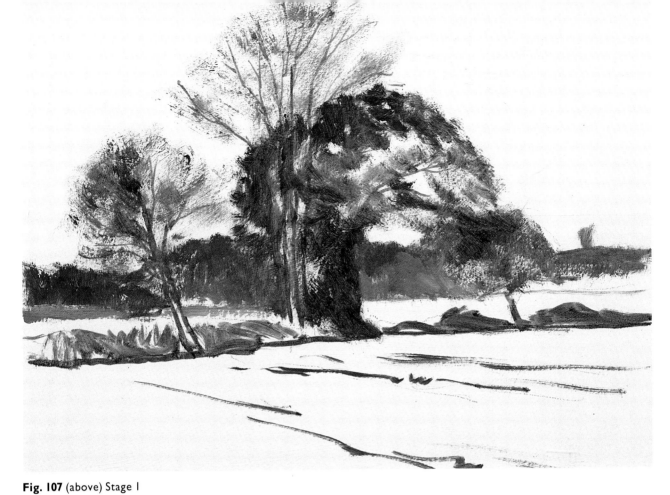

Fig. 107 (above) Stage 1

Fig. 108 (below) Finished stage, Primed Whatman paper, 25 × 30 cm (10 × 12 in)

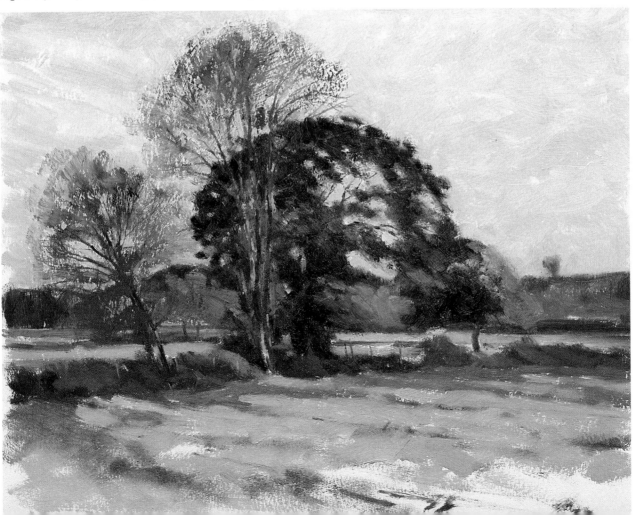

Poplar trees are a simple shape to draw. When you paint them work your brush strokes in the direction of growth and movement. In **fig. 109** you can see that the poplars are gently blown by the wind in one direction, and that is the direction I have painted my brush strokes (**fig. 114**). Note the brush strokes of sky colour I have painted over the trees (**figs. 110** and **111**).

When you are painting trees from nature, don't labour when you are copying them. It doesn't matter if a branch is too long or too high, too low or too thick in your painting compared with the real tree. The object is to get the general feeling of the tree. Usually this is achieved by the shape and general character. Look again at **fig. 114**. If I had made the poplars shorter and wider, they wouldn't have looked like poplars. The branches and areas of leaves on the willow trees in **fig. 115** are not exactly the same as on the real trees (**fig. 112**), but their character has been captured. I drew the trunks and branches first with my No. 6 sable brush and my rigger. Then I painted over the dark areas of the foliage with my No. 4 brush, using dry brush strokes. I worked over the branches again and, finally, using my No. 4 brush with thicker paint and a very gentle dry brush stroke, I worked the light areas of the leaves (**fig. 115**). The 'white' flecks of light on the foliage are where the first dark areas of the leaves were put on with dry brush strokes; it is the white of the paper ground that is showing through. As you can see, most of the foliage on these willows was achieved by using the dry-brush technique (**fig. 113**).

Do practise your trees – it's well worth while.

Fig. 109

Figs. 110 and **111** (above) Details from the finished stage, **fig. 114**

Fig. 114 (opposite, above) Finished stage, Primed Whatman paper, 25 × 30 cm (10 × 12 in)

Fig. 115 (opposite, below) Finished stage. Primed Whatman paper, 25 × 30 cm (10 × 12 in)

Fig. 112

Fig. 113 (below) Detail from the finished stage, **fig. 115**

SIMPLIFYING WATER

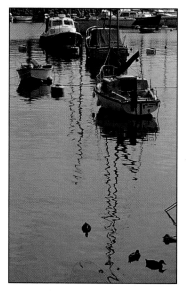

Fig. 116

Fig. 117 (below) Detail from the finished stage, **fig. 120**

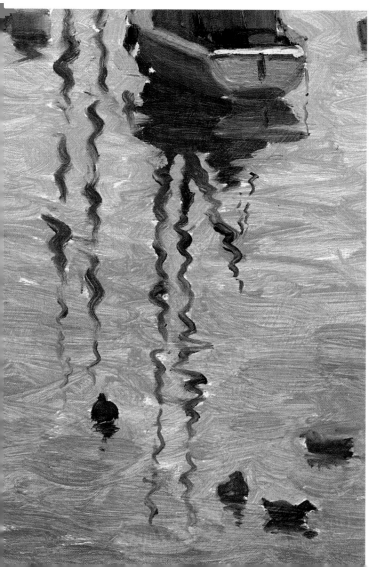

One of the secrets of painting water is to keep it simple. It's not what you paint but what you don't paint that can create the illusion of water on a canvas. Look at **fig. 118** opposite. In A I have painted a post on white sketching paper. In B, to make the post appear to be standing in water, I have painted another post underneath it: a reflection. It now looks like a post standing in water – and the water is not even painted; it's white paper. To create an even greater illusion of water, I have given movement to the reflection with a simple brush stroke (C). In D I have put in a Cobalt Blue and Titanium White area for the water, then painted my reflection on it while it was wet. This gives as much illusion of water as C. So it is important to remember that, more than the colour of the water, the reflection image gives the illusion of water. Notice also that in D the post leans to the right and the reflection leans the opposite way – a rule that applies to all reflections. Naturally, in fast-moving, broken water the reflections do jump about a bit but, even so, you must stick to the rule.

When you are out, find some water where you can sit and observe it at length. You don't need your paints at first. If possible, find calm water to begin with. When you look at it, naturally, it will look like water – but you must not see it as water; you must see it as a painting. To do this, you must understand it. Look closely at the surroundings, making yourself familiar with the reflections, or at least what you could expect to see reflected. Then observe the water closely, looking for the shapes of reflections only. Don't be put off by movement on the water, such as ripples, flotsam and jetsam, and so on. Concentrate the mind solely on the reflections. Gradually, depending on the clarity of the reflections, you will be able to make them out. Now look at the real thing, and again, against the reflection; you will see that the colour of the water is made up of the reflections and another colour – a 'non-reflected' colour. Water usually reflects the sky, so this additional colour can be blue or a warm grey, and so on. If the water is muddy, the reflection is usually one colour, because dirty water does not always reflect colour.

As a general rule, anything above the water is reflected into it, if not in colour, then in shape. In still water the reflections are mirrorlike, but in disturbed water the reflections can be broken, forming many other odd shapes.

The reflections of the boats and masts in **fig. 120**

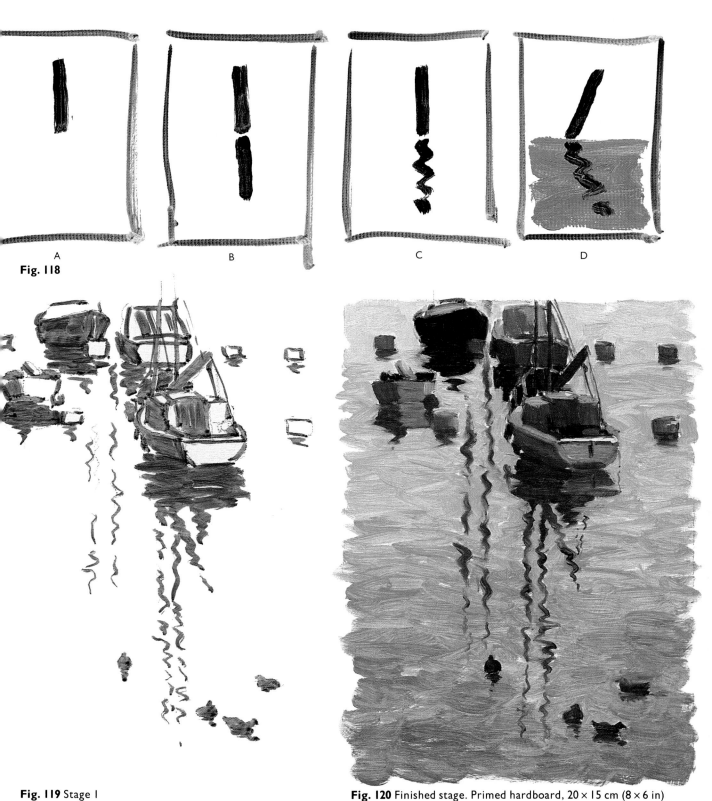

A B C D

Fig. 118

Fig. 119 Stage 1

Fig. 120 Finished stage. Primed hardboard, 20 × 15 cm (8 × 6 in)

opposite are done very simply, just the same as the posts. In Stage 1 (**fig. 119**) I painted in the boats and mast reflections with a turpsy wash of Cobalt Blue and Crimson Alizarin, using my No. 1 brush. The rigging was put in with a rigger brush. Note how freely the reflections were painted in. The broken line of the mast reflections shows movement of the water, as in the post reflection (**fig. 118**C).

In the finished stage (**fig. 120**) I painted the boats

first, using my No. 2 brush. After painting each boat, using the same brush with the same 'boat colour' on it, I painted the reflection of that particular boat, not the masts. Then, with my No. 4 brush, I painted in the water, making it slightly darker as I worked down the painting. Finally, I painted the reflection of the mast into the wet sea paint, with my No. 2 and No. 6 sable brushes. This was exactly the same procedure, but a little more elaborate, as I used for the post in **fig. 118**D.

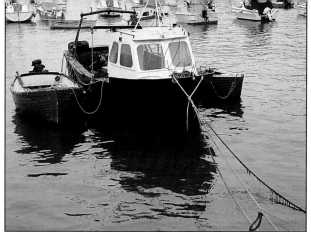

Fig. 121

Fig. 122 Stage 1

Fig. 123 Finished stage. Primed hardboard, 15 × 20 cm (6 × 8 in)

The water I painted in **fig. 123** is a very good example of the way brush strokes give the impression of rippling water. If you look at the photo in **fig. 121**, you will see how the bottom of the reflection in particular is broken by the movement of the water. When you are painting a reflection like this, don't try to copy exactly what you see. Look at the reflection and watch its movement. When you paint it in, make a similar movement with your brush. In the close-up illustration, **fig. 124**, you can see that the reflection is made up of individual brush strokes which are joined together in some areas and not in others. I used my No. 4 brush for this; if I had used my No. 2 brush, the ripples would have been smaller.

In painting a reflection like this, the size of brush determines the movement of the water. If your reflection began across a lake or a wide river, you would have to start with smaller brush strokes, making them larger as they approached the foreground, to create perspective. This is pretty obvious, but very important, as it helps to make the water appear flat and to create the impression of distance.

I painted a turpsy wash of Cobalt Blue and Crimson Alizarin on primed hardboard first and let this under-painting be the water (Stage 1, **fig. 122**). Note that the colour is different from that in the photograph in **fig. 121**. I did this to illustrate that it is the reflection that suggests water in a painting, more than the colour of the water. If I had painted the water red and then put in the reflections, it would have looked like red water. Look at some of my other paintings in the book which have water in them and analyse them. You will see that the water is made up of reflected and non-reflected areas (the sky) and that the brush stroke plays a very important part – in the application of the paint – in creating the illusion of water.

The painting in **fig. 125** is of a loch in Scotland, where the water was very still. I didn't suggest any ripples or movement of water in this painting because of its scale. They would have been almost too small to paint and so, if I had painted them, I would have had to paint a very detailed foreground in order to make it look part of the same picture. So any movement on the water is left to the onlooker's imagination.

When you paint the sea the rule is that the horizon must not be in the centre of the picture; it is not considered to be good design, and I agree. The same rule could apply to my painting of the loch, where I have placed the horizon in the centre. However, because the water is so dark on the horizon, and the mountains are dark and above the half-way mark, the picture is not divided in two.

Fig. 124 Detail from the finished stage, **fig. 123**

Fig. 125 (above) *Scottish loch*. Primed hardboard (reproduced actual size)

Fig. 126

LESSON 20

SIMPLIFYING BOATS

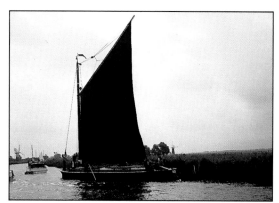

Fig. 127

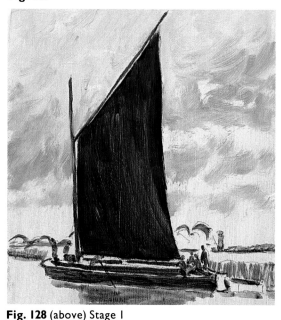

Fig. 128 (above) Stage 1

Fig. 129 (below) Finished stage. Primed hardboard,
20 × 15 cm (8 × 6 in)

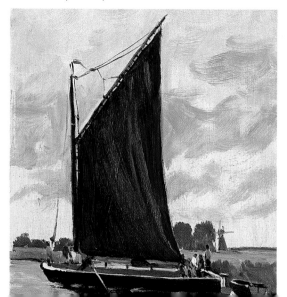

I love to paint boats, especially in a complicated harbour scene. I am just as happy to paint such a scene at low tide, when all the boats are resting on thick wet mud, or at high tide, when the harbour is full of boats bobbing up and down, and the reflections are dancing and playing on the water. Yet even a solitary boat can inspire me. I suppose one reason is that I am confident in drawing them. I have found that the students who are not inspired by boats are those who find it difficult to draw them.

When you start to practise drawing and painting boats, first observe, and then simplify. Find some boats and just observe them at first. Then use your sketchbook and sketch them in pencil. Don't try a clinker-built boat first (they are the ones with the hull made of planks and you could get into difficulties trying to fit these into the overall shape). The white and black rowing boat in **fig. 130** opposite is clinker-built, but I have only **suggested** the planks with a broken thin line. The fishing boat (**fig. 130**, bottom left) is built in the same way but I have simplified it and have not painted the planks in. They are left to the imagination – so you can cheat a little!

The small yacht and dinghy (**fig. 130**, top left) are painted very simply, yet they are convincing enough for any painting. Work your boats as simply as this to start with and soon, practice and experience will lead you on to the more 'worked' boats like the fishing boat or the one opposite, top right.

The boat at the bottom right, which I saw in a river estuary, is so full of character that I had to paint it. Remember, you are painting boats, not building them; they haven't got to sail. But you must observe them so that you can make them look as technically correct as possible. You must give the impression of seaworthiness.

The boat in the photograph on the left (**fig. 127**) I saw on the Norfolk Broads; it is called a wherry. Look how simply I painted the hull: three brush strokes – one for the main hull, one for the cabin side and a thin white brush stroke separating the two. When I painted in the sail I wiped out some paint with a rag to represent the folds and to give it movement. Remember that you can take off paint, as well as put it on the canvas, to achieve the results you want.

One last word. On our courses we take the students to a small harbour for a day's painting. Those who are not confident at drawing boats are always pleased and surprised at their results; so do try.

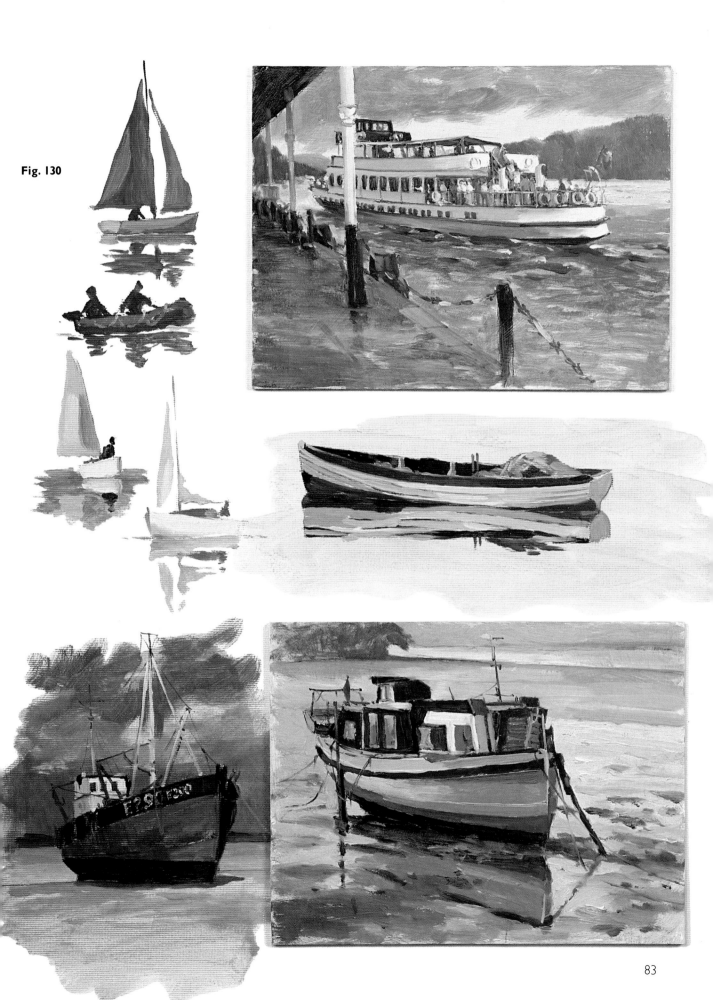

Fig. 130

SIMPLIFYING SKIES

The sky, where it plays an important role in a painting, is usually the part that conveys the mood of the picture. In a landscape or a seascape, the sky can give the impression of a rainy day or a sunny day, evening or dawn, a windy day or a cold day, and so on. So it is essential to master the sky as a subject.

When I paint in watercolour or acrylic colours, I always paint the sky first. When it is dry, I paint over it with trees, hills, etc. and I find that everything else naturally follows the sky's mood. But when I use oil paint, depending on the subject, I can't always put in the sky first because the paint would be too wet to work over. I could wait for it to dry, of course, but **this could take up to a week**, depending on the amount of Alkyd Medium mixed with the paint, and how thick the paint was on the canvas. As most of my oil paintings are done in one sitting (from half an hour to two or three days, depending on the size and subject) I am not usually working on dry paint. So, when you paint a scene where trees or buildings are against the sky, first paint the sky, working around (not over) the area where the trees or buildings are to be put in. Then, when you come to paint them, you will not pull up the wet paint of the sky. You may find this a little restricting at first because one of the beauties of painting the sky is the tremendous freedom of brush stroke you have, working over a large uninterrupted area. Alternatively, you can paint the sky last and work up to the background shapes.

When I painted the sky in **fig. 132** opposite my brush really danced around the cloud formation without restrictions, apart from the end of the canvas and this can be annoying at times. You can see that I like painting skies.

I suggest you practise by copying from nature; but only simple skies. Try clear skies, a cloudless sunset where the colours of the sky graduate down to the horizon. Then try a sky with clouds, but make it a day with only a light wind, when they are very high. Then they will stay in their formation long enough for you.

When you feel confident, try a windy day with plenty of clouds scudding across the sky. First watch them, observe the pattern, then with a turpsy wash draw in a group of clouds as they are passing. You won't see these again, but apart from the shape, the sky will look roughly the same. So you use your drawing and paint the tones and colours from other clouds as they pass your view. Don't try to paint larger than 25 × 30 cm (10 × 12 in) because you will have too

Fig. 131

much canvas to cover, and time is not on your side.

You can also practise your skies in a similar way, but using a 2B pencil on cartridge paper. This concentrates your mind on shape and tone; you don't have to worry about colour.

Working from nature, it won't take you long to understand the sky and you will be able to paint a sky indoors, either from memory or from your colour or pencil sketches. Always put in some simple landscape to give your sky dimension and scale, and show the tonal values between sky and land.

The sky in **fig. 132** opposite is painted on a rough jute canvas 41 × 30 cm (16 × 12 in), on a white ground. I used a No. 6 and No. 4 brush throughout the sky. First I put in the dark areas of the clouds, then I gradually worked up to the lightest parts. I feel I could have added a little more subtle colour to the clouds, but apart from that I am happy with the result.

The four sky sketches in **fig. 133** opposite were all painted on oil sketching paper, fine grain, 13 × 20 cm (5 × 8 in). I gave the top two a turpsy wash of Yellow Ochre; I worked the other two straight on to the white surface. I didn't draw any of these skies or put on any thin turpsy under-painting; I worked straight in with the paint, using a No. 4 and No. 2 brush. When you are painting skies, you have the best opportunity to paint wet into wet, and merging and mixing colours and tones on the canvas. This creates soft 'cloudlike' edges and varying subtle tones and colours.

For me this is where oil paint really comes into its own – painting skies. I hope you will get as much enjoyment as I do from painting skies in oil. Practise! Copy my skies before you try from nature; it will give you more confidence.

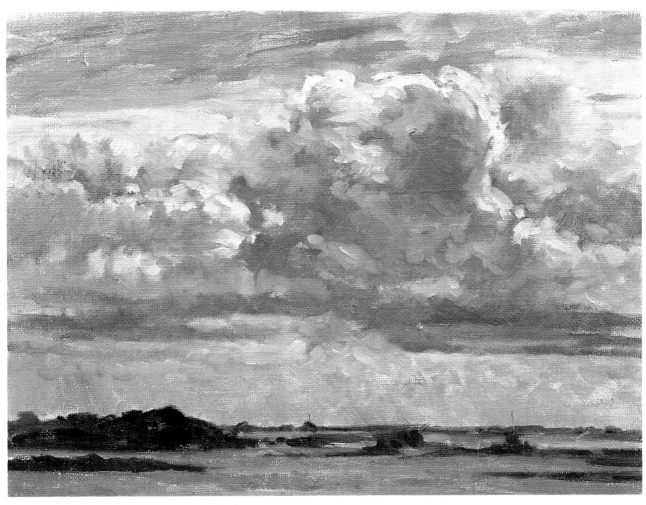

Fig. 132 (above) Canvas, 30 × 41 cm (12 × 16 in)

Fig. 133 (below) Four sky sketches. Oil sketching paper, fine grain, each 13 × 20 cm (5 × 8 in)

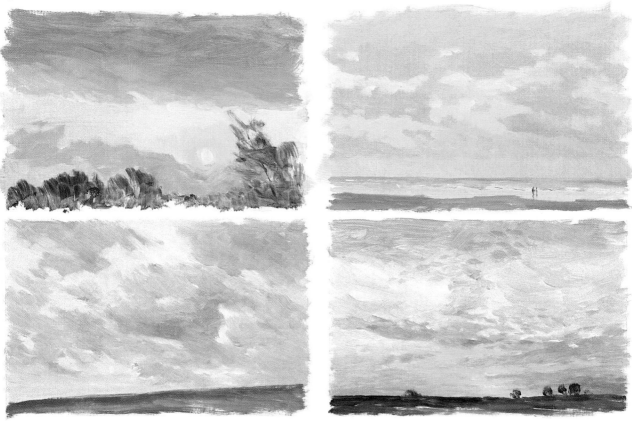

Fig. 134

In the painting opposite (**fig. 137**), which I worked over a Yellow Ochre turpsy wash on primed Whatman paper, I first drew in the main cloud formation with my No. 2 brush, using a turpsy mix of Cobalt Blue, Crimson Alizarin and a touch of Yellow Ochre to help give the painting a subtle greeny colour of a late-winter afternoon (**fig. 136**). I then filled in the dark cloud areas and trees with my No. 6 brush and the same turpsy mix.

With the same brush I worked in the dark clouds, using a mix of Titanium White, Cobalt Blue, Crimson Alizarin and Yellow Ochre (**fig. 137**). Note that I didn't paint any of this sky under the trees; I let the turpsy wash represent this so, when I worked the trees later, the wash was dry and I could paint in the branches

Fig. 136 Stage I

easily. But I did paint a few small areas of sky into the trees after I had painted them in, to give them a little more depth and form (**fig. 135**). I discussed this in Lesson 18, page 74.

Next I added the blue sky and some more moulding on the clouds, but not on the sunlit area behind the trees. I put in the branches of the trees with my No. 6 sable and rigger, and added some dry brush strokes over them with my No. 6 brush, to give them more character. Using a mix of Titanium White, Cadmium Yellow and Crimson Alizarin, I painted the sunlit areas. Then, over this light colour, I delicately dragged some very light blue sky colour to the right of the main tree. Finally, I added a few more branches to the trees to give them more shape.

Fig. 135 Detail from the finished stage, **fig. 137**

Fig. 137 Finished stage, Primed Whatman paper, 25 × 30 cm (10 × 12 in)

SIMPLIFYING BUILDINGS

Fig. 138

Some students don't like painting buildings, usually because they are not confident about drawing them. Of course, these students, like those who don't like drawing boats, will not improve because they won't try to paint buildings. So they are stuck, and they can't use buildings as a subject.

The way forward is actually to paint them. Don't worry whether you get good results or not; remember that every painting you do gives you more knowledge, which in turn gives you more confidence, and with more confidence your painting improves.

To begin with, practise drawing parts of a building. Take your sketchbook and pencil and first, just look at a building. Perhaps you can do this from your window at home, where you are not overlooked and you will not worry about anyone seeing what you think is not a good drawing. Sit comfortably, relax, and **observe** the building in front of you. You will see things that you have never bothered about before. For instance, the chimney-stack is bigger than you thought in comparison with the house; the eaves and gutter protrude over the wall of the house, in most cases quite a distance; the window-frames are thicker than you expected, and so on. If you observe buildings you will feel more confident to try drawing them.

Think of your favourite painting subject for a moment. Even in your mind's eye, you can see how the subject looks. If it were trees, you could see in your imagination how they are constructed and therefore how to draw them. That is because you have observed

them and practised drawing and painting them. Naturally, it seems easy to paint them – now. Subjects you know and understand seem easier than those you have avoided.

When you have observed your building, draw in your sketchbook parts of the building in isolation – the windows, a door, chimney-pots etc. This will make you familiar with those parts of the building, and the whole building will then seem less formidable.

Opposite, I have shown you how I simplified a painting of the Doge's Palace in Venice (**fig. 141**). It may look complicated, but study it carefully. I drew it in with my No. 2 brush on a Yellow Ochre and Crimson Alizarin wash over primed hardboard. You can see how freely this was done in **fig. 139**. There is no detail work at this stage at all. Then, using my No. 4 brush, I painted in the grey-coloured areas. The gold and coloured work in the arches was done, again very freely, with a No. 2 brush, letting the background ochre-colour show through in places (**fig. 140**). Also, look how simply and freely the figures are painted on the dome. In **fig. 142** you can see how unlaboured the work is in the doorway and the people.

I am not saying that the painting is simple to do. What I want you to accept is that when you paint buildings you don't have to do it as an architect would. The brush strokes can be free and unlaboured. Try to approach painting buildings with this aim in mind and you will see an improvement immediately. This doesn't mean that you can't or shouldn't paint

Fig. 139 (above) Stage 1

Fig. 140 Detail from Stage 1, fig. 139

Fig. 141 (below) Finished stage. Primed hardboard, 25 × 30 cm (10 × 12 in)

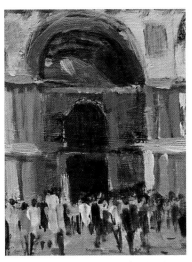

Fig. 142 Detail from the finished stage

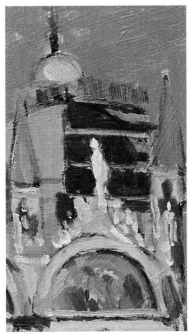

Fig. 143 Detail from the finished stage

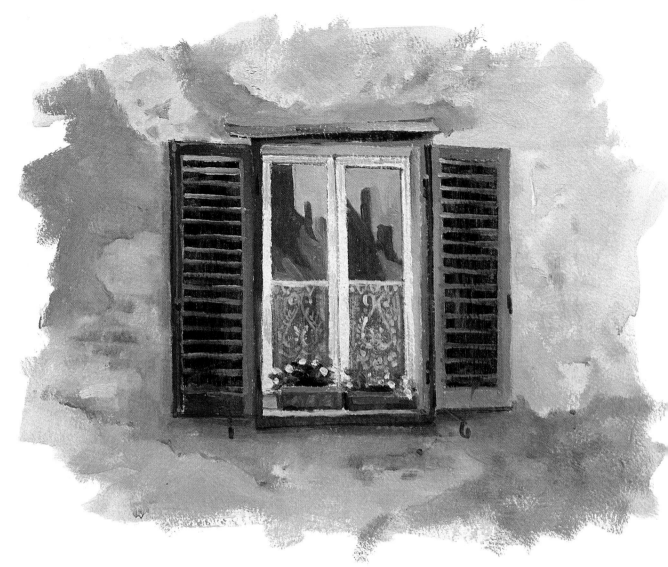

Fig. 144 *The Window*. Primed Whatman paper, 20 × 28 cm (8 × 11 in)

buildings with very careful detail work, but I recommend that you start your buildings by working them very freely.

After sketching buildings in pencil, try painting them. Again, paint only parts of buildings to start with. In **fig. 145** opposite I have painted on hardboard some parts of buildings. Look at the bricks: first I painted a dark ochre wash then, with a No. 2 brush, I added the bricks over the wash. The brush was just the right size for the width of the bricks – lucky me! Look at the bottom three rows: I painted in the mortar in between the bricks with a lighter yellow colour, using my rigger brush. Because of the way I have painted them they look very detailed and precise. That is just one way of painting bricks, and only if you want them to look precise.

I have painted the chimney-stacks below in the same way, using my No. 1 brush, but I have let them join up in places and have not allowed much under-painting to show through for the mortar. I have suggested them, not painted them. It is important to practise painting bricks – they do crop up frequently in buildings!

When you paint plastered walls make sure that you change the colour or tone, to give life and variation to the area, otherwise it can look very flat and boring. Notice how interesting the wall looks around the door in the top right of **fig. 145**. Note also how the colour of the door changes almost from panel to panel. But if the door were part of a large building, in a painting of that building the door might not be so detailed as my door because it would not be important enough in the whole painting.

The windows, top left of **fig. 145**, are not detailed like the windows in **fig. 144**, which even show net curtains and the reflections of the neighbouring houses. That is because the window **is the painting**; in **fig. 145** the windows are only part of the painting. Look again at **fig. 141**: the windows in the Palace are only brush strokes because they are only a small part of a larger structure. Remember, the further away and the more complicated the building, the less you must paint their features. In fact, as buildings fade into the distance, windows and doors can even be omitted.

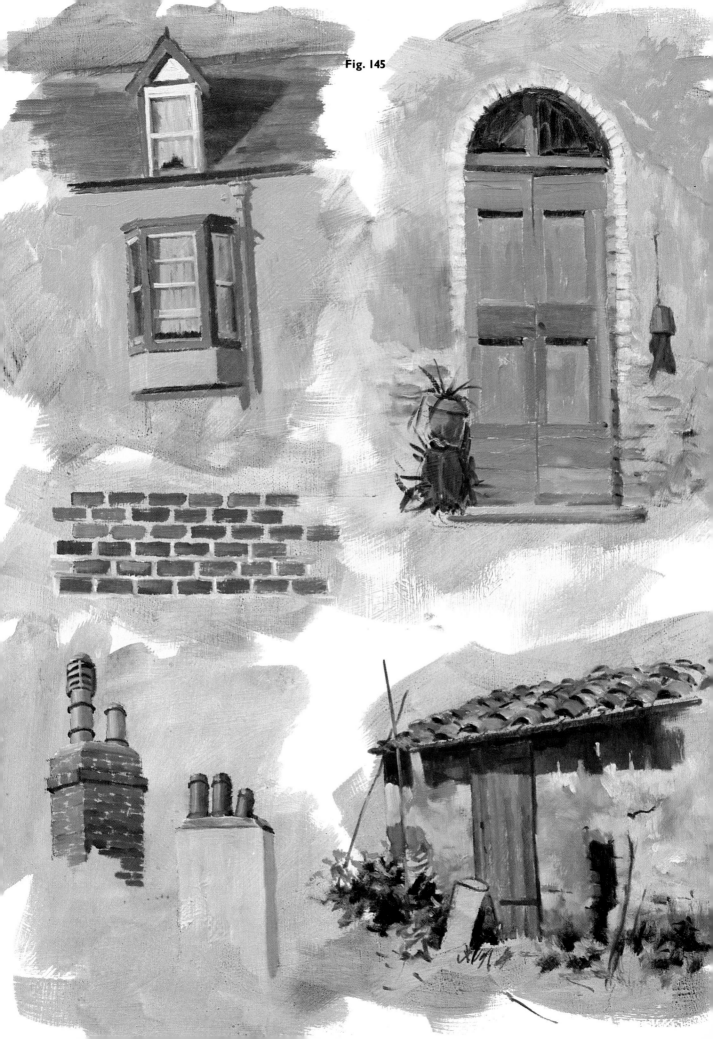

Fig. 145

SIMPLIFYING ANIMALS

Fig. 146

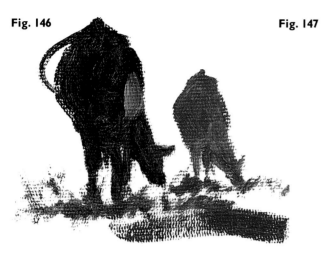

Fig. 147

If you had problems with moving clouds, then you will encounter a few more with animals! They won't keep still, unless they are asleep or eating. Because of this, many artists work from photographs, and there is nothing wrong with this at all; in fact, I recommend it. It teaches you much about animals. But one very big word of warning: photographs should be used only after you have studied the animals and drawn or painted them from life.

Let's imagine you are painting heavy horses. When you are close to them you can **observe** them: you can see the length of hair, the whiskers around the mouth, the wetness around mouth and nostrils, the steam rising from their bodies after working, and the size of their hoofs; you can feel the vibration of the ground as they pass close to you, and sense their enormous size. It is difficult, if not impossible, to see or feel any of this when looking at a photograph. So I suggest a combination of sketching and painting from life, and using photographs.

Whenever I sketch animals I usually take a photograph (slide) of the same animal from as near as possible to the same position as I intend to draw it. Then I have the best of both worlds. I have sketched from life, I have a photograph of the subject and, naturally, I have seen and observed the animal. I suggest that, to start with, you forget about painting animals and concentrate entirely on observing and drawing them.

When I go out on a sketching trip, say to a horse show or a zoo, my first three or four attempts at drawing an animal are usually laughable. I need to sketch for about 15–20 minutes before my brain and pencil work fast enough to capture something of the animals on paper. I find that in the next half hour or so

I do my best work; then my brain seems to close shop, and in the last ten minutes my work goes off again. I think this is because the intense concentration needed to draw models that are constantly moving is very tiring. However, after a ten-minute break, it takes me only about five minutes to get into good drawing again. Animals are a very frustrating subject to paint, and professonal artists have the same problems with them as students do. So I have explained what happens to me in the hope that it will encourage you to persevere and give you heart.

If you have a cat or dog, try to paint that first, but while it is asleep. In fact, next time your cat or dog is asleep, observe it from an artist's point of view. Your skills of observation should be greatly improved by this time.

The two cows in **fig. 146** were painted in silhouette, using a No. 2 brush, without drawing first. This way of painting is ideal for distant cows in a landscape. You need to give an impression of cows, not a portrait of them, otherwise the rest of the landscape would be out of key with the cows.

The horses in **fig. 149** are painted on primed hardboard. I drew first in pencil; then, using my No. 2 brush, I painted a turpsy wash of colour, as if it were watercolour. Notice how the brush strokes go **round** the body and **down** the legs, which established their shape and form. Over this under-painting I applied thicker paint with the same brush. Notice the 'nothingness' area between the two horses' necks and heads and, in contrast, the definite shape of the nose of the left-hand horse; also the dark colour of the right-hand horse – light against dark. The harness was painted last.

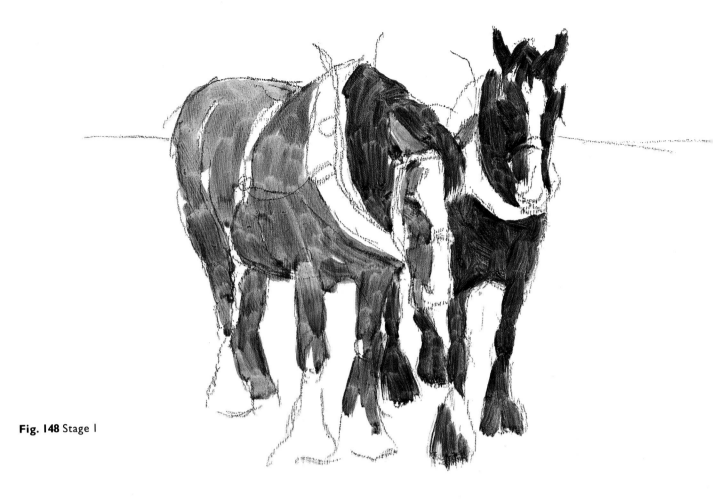

Fig. 148 Stage 1

Fig. 149 Finished stage. Primed hardboard, 15 × 20 cm (6 × 8 in)

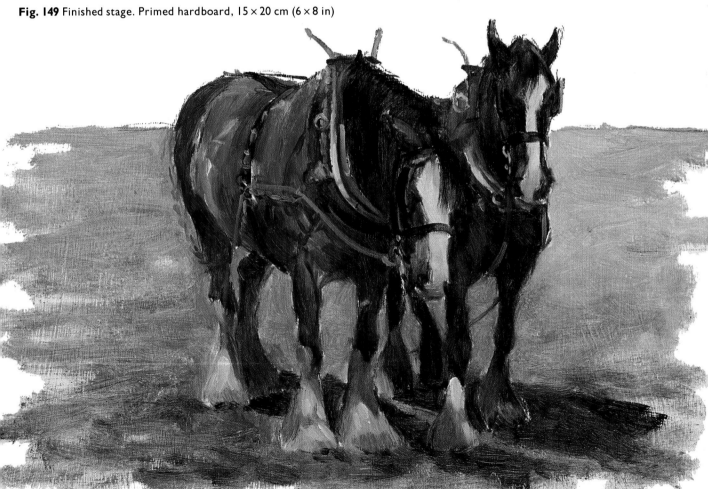

Fig. 150 (left) Stage 1

Fig. 151 (above)

Fig. 152 (below, left) Finished stage. Primed hardboard, 20 × 15 cm (8 × 6 in)

The painting of the cat (**fig. 152**) was done on primed hardboard. Using my No. 6 sable brush, I first drew in the cat then, changing to my No. 2 brush, I painted in the dark areas and then the ginger areas. I left the white of the cat unpainted at this point (Stage 1, **fig. 150**).

In the finished stage (**fig. 152**) I painted in the darker white areas, and then merged the colours together to soften them and given an impression of fur. I painted in the background, then worked on the face with my No. 1 brush, No. 6 sable, and my rigger. Don't worry if the face takes a long time to paint. You will be lucky if you get it right the first time – I didn't! Keep adding and subtracting colour and tone until you are happy with it. I then painted in the lightest white fur with a mix of Titanium White, a touch of Cadmium Yellow and Crimson Alizarin.

For the painting in **fig. 153** opposite I colour-washed a primed hardboard with acrylic colour, using a mix of Raw Sienna, Crimson Alizarin and French Ultramarine. When the wash was dry I painted all the animals with my No. 2 brush, using my No. 6 sable brush for any detail work on the faces. Look at the dog on the left. The movement of hair which helps to show the 'roundness' of the body, was painted with bold brush strokes. All three dogs at the top of the page were painted almost in silhouette first, then I suggested the form by painting brush strokes over them, using a 'blue light' colour on the two right-hand dogs and a 'yellow light' for the labrador in the centre of the page.

Fig. 153

SIMPLIFYING PEOPLE

If only people would keep still! Whether we are sitting on the beach or on a comfortable chair at home, it's amazing how often we move. So painting people is like painting animals and the same rules apply, but at least we can ask a person to keep still while we paint. The purpose of this lesson is to teach you not how to paint portraits but how to paint the people you would find in a painting of, say, a landscape or a town scene – people in the middle distance.

Look at **fig. 154**. The three pink ovals at the top represent heads. I used only one brush stroke for each head, but it is the most important brush stroke of a figure. The first oval represents the head of someone looking down to his right or up to his left; the middle one, someone looking towards us, or a back view; and the third one, someone looking down to his left or up to his right. The four heads in the second row are more animated. The one on the left is looking towards us, the next is looking to his right, and the third is looking to his left; the last is a back view. You can see how this works if you look at the three men in the third row. (Don't put feet on your middle-distance figures – you don't want them to look like the middle one, who resembles Charlie Chaplin!)

For all the figures on these two pages I used primed hardboard painted over with a coloured wash of acrylic paint. When the wash was dry I painted the figures on top, using my No. 1 brush or No. 6 sable. Don't try to paint detail when you work figures like the ones on these pages. Don't fuss over them or you will lose spontaneity and the movement or character of the figure. You will find that in a landscape, figures in the distance will look very convincing if they are painted in silhouette.

The figures at the top of **fig. 156** opposite were taken from the photograph (**fig. 155**) and you can see how I have simplified them. You will find, however, that when you copy from photographs your figures tend to be 'stiffer' than when you work from life because you have more time to sit and think. So, again, work from life and use photographs simply as an aid. When you start a figure, paint the head first, then work down the body to the feet – and don't paint feet unless you feel it is necessary. Look at my people on these pages; there aren't many who have feet.

You can practise painting figures like mine at home. The more you practise, the better they will become, and quite quickly. Once you get into the feel of it, you will really enjoy this lesson.

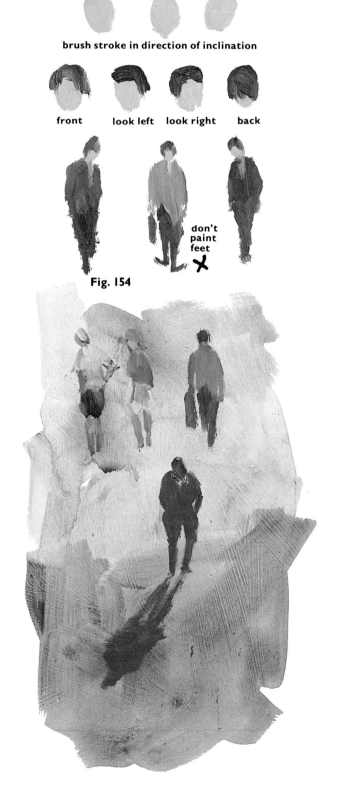

brush stroke in direction of inclination

front look left look right back

don't paint feet ✗

Fig. 154

Fig. 155

Fig. 156 (reproduced actual size)

Part Five
PAINTING FROM A PHOTOGRAPH

PAINTING FROM A PHOTOGRAPH

A camera can be very useful when you are learning to paint, together with learn-to-paint videos, books and so on. You can use photographs as an aid when you are working indoors, but do not imagine that painting from a photograph is a short cut to learning to draw or to paint.

Working in this way presents several problems. In my opinion the biggest is that the scene is 'frozen' and so you can easily spend too much time on your painting. You can also paint details that interest you but they may then be over-worked in relation to the rest of the picture. When you are painting a live scene, details merge into it and do not take on so much importance. From an artist's point of view, another problem is that the camera tends to diminish the middle distance and even with a telephoto lens it seems to flatten the hills. Outdoors, our eyes can focus on the middle distance without distorting it, and isolate it so that we can make a painting of that section of the scene.

Spend a day outdoors experimenting with a camera. Find a scene you would like to paint, make a simple pencil sketch and then photograph the scene from the same viewpoint. Do the same with several different scenes, then compare your sketches with your photographs. Notice what your eye saw and what the camera 'saw'.

Another pitfall is to paint the whole scene in the photograph. Unless you use a telephoto lens, your camera may record much more of a scene that you would choose to paint in real life. I always use transparencies; they are much more three-dimensional when they are enlarged on a screen, and you can make them very big if you want to see more definition or to isolate a small area.

I painted the scene in **fig. 158** before I took the photograph (**fig. 157**), and you can see the difference between what I saw and painted, and what the camera 'saw'. I started the painting below the top of the sea wall because I didn't want the cars in the painting; as a result, I had to paint more beach than is shown in the photograph. I gave this more interest and perspective by enlarging the rocks nearer to me and painting some directional lines and shapes down the beach. The ladders are important because they help the eye to go up the sea wall, out of the picture. I left out the one on the right because I felt it would have spoiled the composition. I painted the blue boat lighter, so that it didn't merge too much into the background, and I left out the vehicle behind the stern of the white-and-red fishing boat. I also toned down the whites of the boats to give a better balance.

Originally, this painting was done without any thought of comparing it with the photograph, so the pair make a perfect example for this lesson.

In **fig. 160** is a photograph I used for the painting in

Fig. 157 (below)

Fig. 158 (right) *White and red fishing boat, Jersey.* Primed Whatman paper, 25 × 30 cm (10 × 12 in)

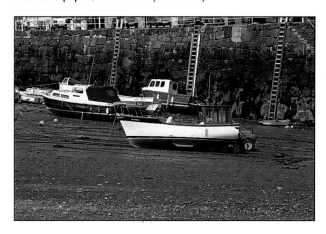

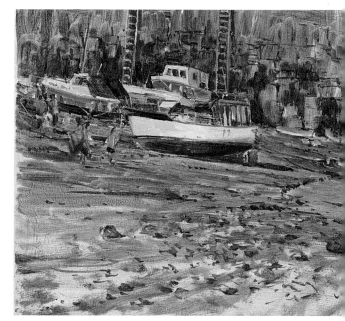

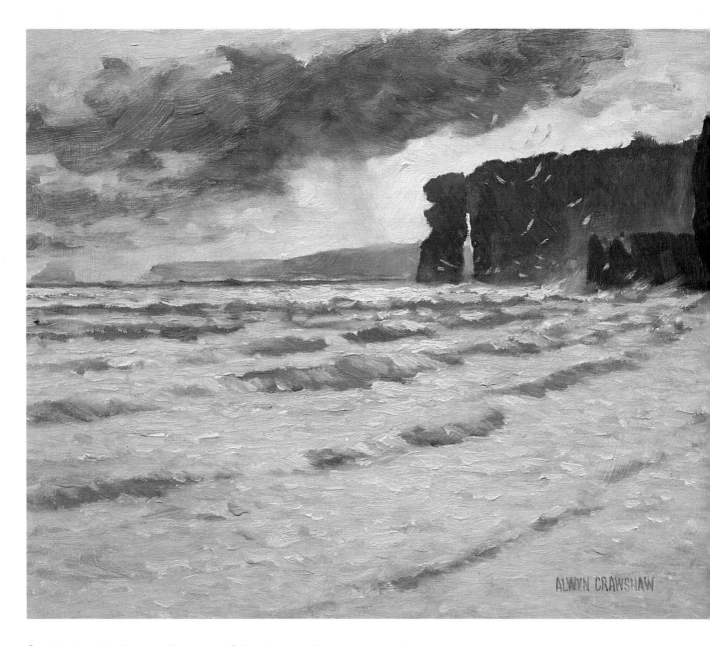

fig. 159. I used only a small section of the photograph, and notice how I painted the waves at a sharper angle than they run in the photograph. This has given more dimension to the scene. I have also put some character into the sky, to give strength to the headland.

In the exercise on pages 102–3 it is important for you to see how some of the brush strokes are formed so the close-up (detail) illustrations are reproduced the same size as I painted them. I have also illustrated the method I used for certain parts of this painting and those in the four demonstration exercises that follow; the arrows indicate the direction of the brush strokes and the movement of the brush (see Lesson 3, page 22). In the following exercise and in Demonstration 3, page 114, the finished stage is reproduced the same size as the original picture. I made them this size, first, to show how we can paint small with oil, and second, so that you would be able to see the paintings reproduced actual size.

Fig. 159 (above) *Headland from Dawlish*. Primed hardboard, 20 × 25 cm (8 × 10 in)

Fig. 160 (below)

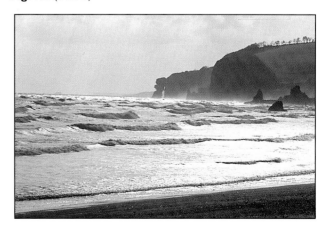

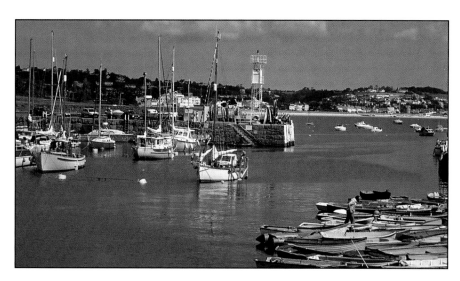
Fig. 161

Start the exercise by taking a good look at the photograph (**fig. 161**) and the finished painting (**fig. 169**, page 105). First of all, you'll notice that I did not paint the whole photograph. I didn't want all the rowing boats in the picture; they'd have looked very unattractive, perhaps unrecognizable, and just a jumble. I wanted the main white boat to be the centre of interest, and so I closed in to achieve this. I painted the red boat grey, as red would have been too powerful and dominating in my composition, and I changed the reflections, making the water lighter and the reflections dark. Remember, the photograph is to be used only as a guide for the painting. The painting shows the same scene but as seen by an artist, not through a camera lens. I also toned down the white end of the harbour wall and the white buildings in the background to make them recede into the background. I kept the strongest white for the white yacht.

I painted this on a white primed canvas 25 × 30 cm (10 × 12 in).

Stage 1

Draw in with a HB pencil. With your No. 2 brush, draw over your pencil and fill in areas, using a Cobalt Blue and Crimson Alizarin turpsy wash. Paint in the masts with your No. 6 sable brush, using a mahl stick to steady your hand.

Stage 2

Start by painting in the background hill and buildings – use your No. 4 brush to ensure that you do not make it detailed (students tend to do this, especially when copying a photograph). Look at the finished stage (**fig. 169**, page 105) to see how freely I painted it. Now paint the two jetty walls. When you paint the main jetty continue the colour, but a little darker, into the water for the reflection. Finally, paint the distant beach on the right of the picture. Notice that so far I haven't attempted to put in any detail.

Stage 3

Using your No. 2 brush, paint in the boats, the cars, the grey building, and bits and pieces on the jetty wall. Keep it very simple. Next, paint in the boats on the water. The yellow boat colour is mixed from Titanium White, Yellow Ochre, and a touch of Crimson Alizarin, with Cobalt Blue added for the darker areas. The main white boat colour is mixed from Titanium White, a touch of both Crimson Alizarin and Cobalt Blue, and the lightest part is Titanium White with a touch of Cadmium Yellow. Paint in the sky with your No. 4 brush, using a mix of Titanium White, Cobalt Blue, Crimson Alizarin and a touch of Yellow Ochre. Start on the left of the canvas and make the sky lighter as you work to the right. With your No. 2 brush, paint in the reflections next with a thin mix of Cobalt Blue, Crimson Alizarin, Yellow Ochre and a touch of Titanium White. Look at **figs. 165** and **167**, then the finished stage (**fig. 169**, page 105), and you will see how the yellow boat developed. Even the finished stage detail work is done broadly, and without any 'fussy detail'.

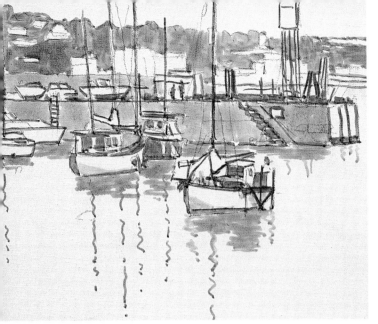

Fig. 162 (left) Stage 1

Fig. 163 (above) Detail from Stage 1, (reproduced actual size)

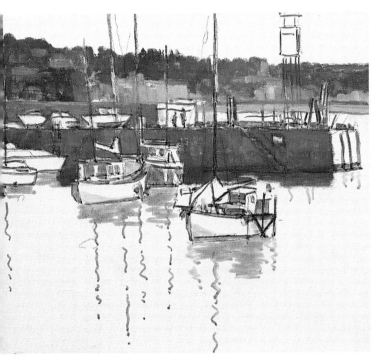

Fig. 164 (left) Stage 2

Fig. 165 (above) Detail from Stage 2, (reproduced actual size)

Fig. 166 (left) Stage 3

Fig. 167 (below) Detail from Stage 3, (reproduced actual size)

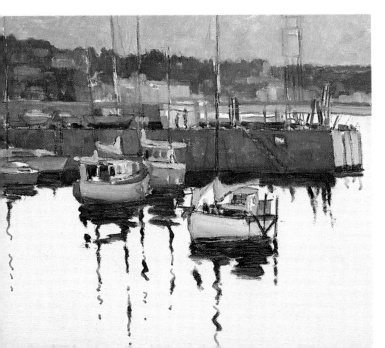

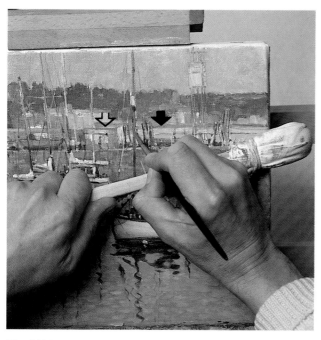

Fig. 168 (above) Paint in the masts and any detail work, resting your hand on your mahl stick

Fig. 169 (right) Finished stage. Canvas (reproduced actual size)

Finished stage

When you look at this finished stage remember that the illustration in **fig. 169** is the same size as the original painting. Using your No. 6 brush very dry, and a light yellowish-white mix, suggest the stone wash on the jetty wall by working your brush on the canvas in a flat position. Now paint in masts, rigging and any detail work, using your No. 6 sable and rigger brushes, and supporting your hand on your mahl stick (**fig. 167**). Add the structure on the end of the jetty with a white box-like top to it.

Relax now after the detail work, and mix Titanium White, Cobalt Blue, Crimson Alizarin and a touch of Cadmium Yellow for the sea; use your No. 6 and No. 4 brushes to paint it, and make it darker as you come to the bottom of the canvas. Paint into – and in places over – the reflections. Make short brush strokes with your No. 4 brush to add some lighter colour over the foreground darker sea, giving it a delicate dappled-sunlight effect. Put back some of the reflections. Use your No. 2 brush to paint in the light colour of the jetty steps.

At this stage you must look at **your** painting and decide what to do to finish it. You may need some more highlights or dark accents, so look carefully to make these final decisions.

Remember that photographs can't take over from nature but they are a good and practical aid to painting. Never be afraid to use them to work from.

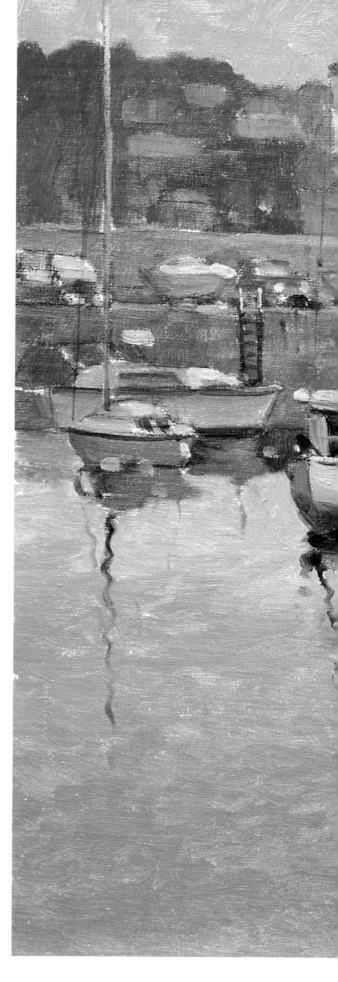

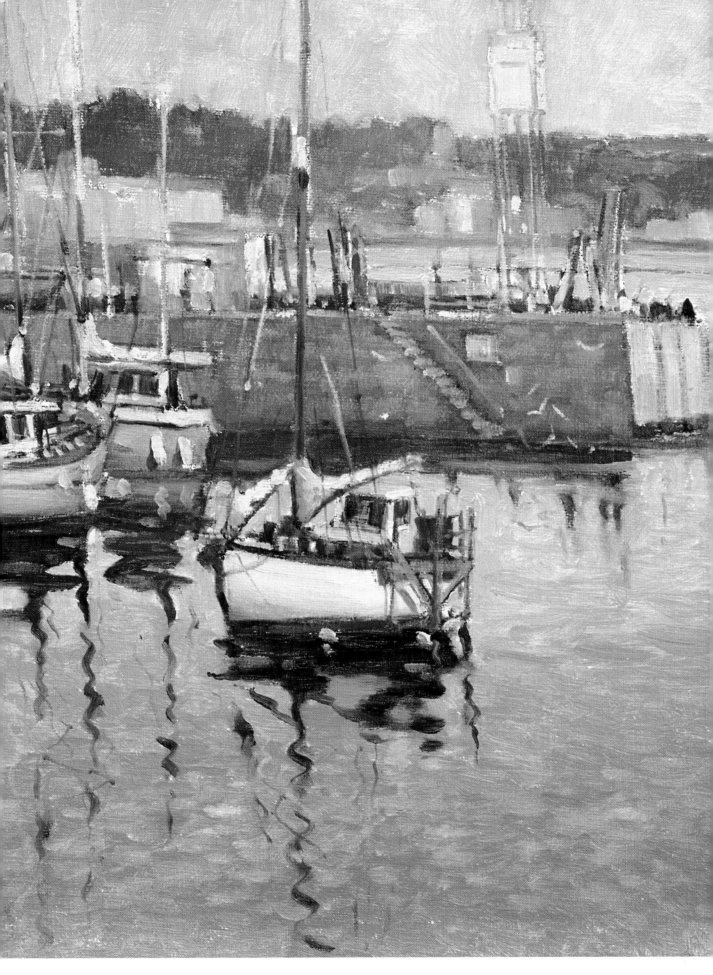

Part Six
DEMONSTRATIONS

ALWYN CRAWSHAW

SNOW LANDSCAPE

This exercise brings together three of my favourite painting subjects: trees, water and snow. The snow covers up much of the detail work, and you need to concentrate more on tonal work than on drawing. Trees need to be drawn, of course, but the accuracy of the branches is not critical, unlike the mast and rigging of a yacht. Once the river is drawn in and established on your canvas, it relies on colour and tone to give the illusion of water.

I used primed hardboard and painted over it a wash of acrylic colour, using a very free mix of Raw Sienna, Crimson Alizarin and French Ultramarine. You can see in Stage 1 (**fig. 171**) how I let the brush strokes show when I painted it.

Stage 1
Draw in the main features with your No. 2 brush, and use your No. 6 sable brush for the smaller branches of the trees – use a turpsy wash of Cobalt Blue and Crimson Alizarin. Then paint in the dark areas of the trees. Finally, keeping your brush strokes horizontal, add the reflections.

Stage 2
Mix Titanium White, Cobalt Blue, Crimson Alizarin and a touch of Yellow Ochre, and use your No. 2 brush to paint in the distant hills, working in between the trees and painting within the main group of trees, so that you can see through them. Using the same colours but with more Yellow Ochre and Crimson Alizarin added, paint in the hedges. Change to your No. 4 brush

and, still using the same colours, paint in the trees, working from left to right – use a dry brush over the sky areas. Make the colour warmer, take your No. 6 brush, and paint the main group of trees. Finally, add the same colour to both banks of the river, where the ground is not completely covered by snow.

Stage 3
Now paint the sky. Mix Titanium White, Cobalt Blue, Crimson Alizarin and a touch of Yellow Ochre. Start at the top, using your No. 6 brush, and as you work down the sky add more Yellow Ochre, then Crimson Alizarin, and use less Titanium White. Work freely and, as you change colour, work the brush strokes back into the previous colour so that you get a natural variation down to the horizon, but don't overdo the mixing on the canvas. Paint up to the trees and let the brush go over them in places, and over the background hills. With thin paint and a dry-brush technique paint over the tree with a lot of branches that sticks out at the left of the main group. With your No. 1 brush paint the sky colour between the branches of the main trees.

Finally, paint in the snow. Prepare a mix of Titanium White, Cobalt Blue, Crimson Alizarin and a little Yellow Ochre. Don't over-mix on the palette – allow for some mixing as you paint. Concentrate on the darker to middle-tone snow; the lighter areas can be worked later. Use your No. 2 brush, and begin with the distant fields, working in between the trees. The sun is on the right of the picture so the right-hand bank is in shadow. Notice how dark this is.

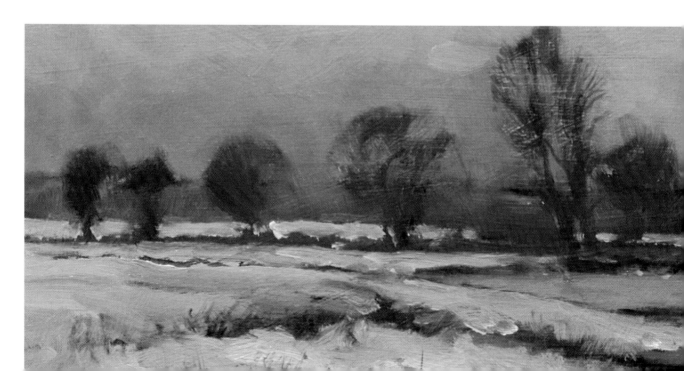

Fig. 170 (opposite, below) Detail from the finished stage, **fig. 176**, page 111

Fig. 171 Stage 1

Fig. 172 Stage 2

Fig. 173 Stage 3

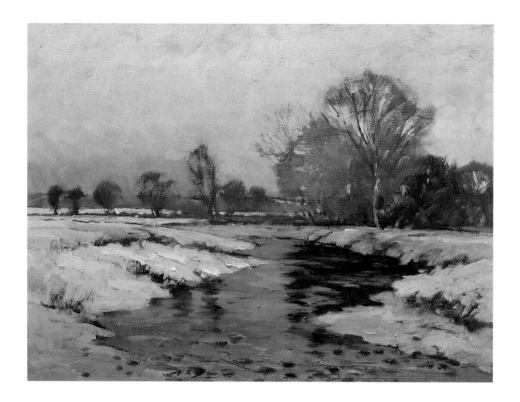

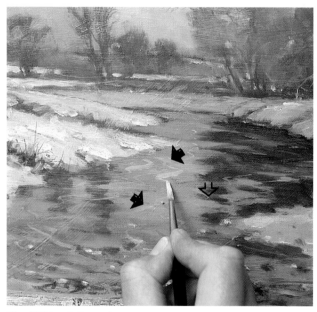

Fig. 174 (top) Stage 4

Fig. 175 (above) Paint in perspective movement lines on the river with your No. 6 sable brush

Stage 4

The beginning of this stage is a continuation of painting the snow. This time, use your No. 4 brush as you work towards the foreground. For the lighter areas use more Titanium White, and where the sun is on the snow use Yellow Ochre with Titanium White.

Now for the river. With your No. 4 brush and a thin mix of Cobalt Blue, Crimson Alizarin, Yellow Ochre and a touch of Titanium White, paint the reflections over your original under-painting. Paint over the stones in the river and add a few more; later these will be painted over with the river colour. The light-coloured water is painted with a mix of Titanium White, Cobalt Blue, Crimson Alizarin and a little Yellow Ochre. Use the same brush, start at the top of the river and work down, using horizontal brush strokes. Let some brush strokes work into the reflections. Leave the Raw Sienna under-painting to show through the river where your brush strokes accidentally don't cover it; this adds more life and movement to the river. When you get to the foregound of the river, leave large areas showing to give the impression of the river bed, where the water is shallow and you can see the bottom.

Finished stage

The illustrations of Stage 4 and this stage (**figs. 174** and **176**) look very similar but, if you look closely, you will see how the following slight changes improve the painting. At this stage of an oil painting your palette should be full of little areas of paint that have been mixed but not used up; you still have all the colours you have worked with during the painting so it is easy to find almost any colour you need now for finishing touches. If you find that you need a clean area of your palette, scrape up the paint with your palette knife and put it on the border of your palette. You will then still have some of the mixed colours left to use later. I find this very useful.

Put a little work into the trees by defining some

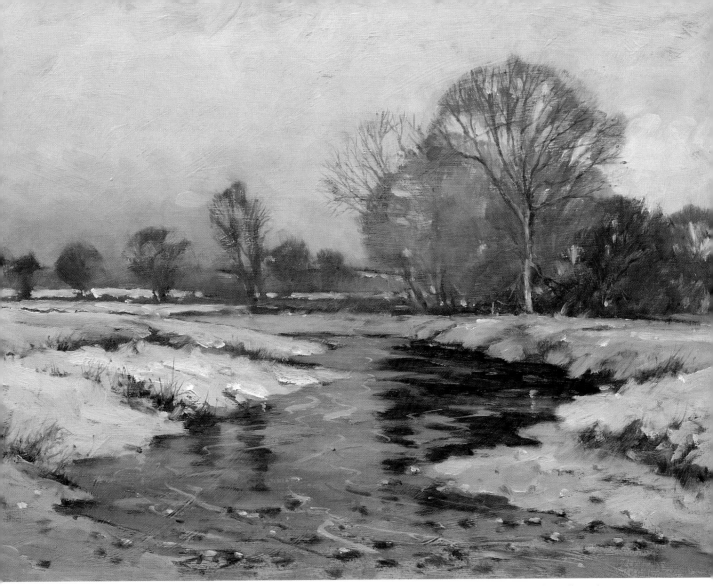

Fig. 176 (above) Finished stage. Primed hardboard, 30 × 41 cm (12 × 16 in)

Fig. 177 (below) Paint back some sky colour between the branches to give the trees more shape

branches with your rigger brush, but don't overdo it. Find a warm colour and add Titanium White to it for the highlight on the main trunk, using your No. 1 brush. Add snow on some of the foreground stones in the river. Now take your rigger brush and paint in some dried grass and winter growth on the banks of the river, above the snow. With your No. 6 sable brush and a 'light sky' mix, paint in perspective movement lines on the river (see **fig. 175**). Practise this brush stroke first on some spare sketching paper; it is very important to create the impression of moving water.

With your No. 2 brush paint the trees behind the main tree a little lighter to give them a better shape and then, using your No. 6 sable brush, paint back some sky colour in between the branches, also to help with their shape (see **fig. 177**).

Look at Stage 4 (**fig. 174**) and then at the finished stage (**fig. 176**): you can see how it helps to put trees behind the foreground tree, because we can understand the form better – we can 'read' it better.

Now look at **your** painting and add highlights and dark accents where they will enhance it.

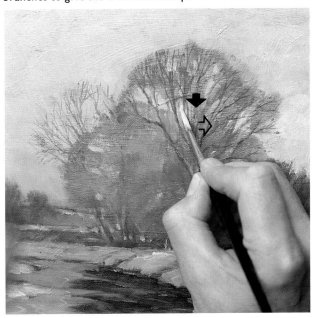

SEASCAPE

The painting in this exercise shows the same beach on which I did the first painting in the book (**fig. 3**, page 8), although the water is not so rough. I worked on primed hardboard and covered it with a Yellow Ochre turpsy wash.

Stage 1
Draw in the picture with your No. 2 brush and a turpsy wash of Cobalt Blue and Crimson Alizarin. Then paint in the tonal areas with your No. 4 brush. Don't try to copy my drawing exactly or you will lose the freedom of your own drawing.

Stage 2
Start by putting in the large field, using a mixture of Titanium White, Viridian, Cadmium Yellow, Cobalt Blue and a touch of Crimson Alizarin: use your No. 4 brush and work the brush strokes in the direction that the field falls. Now mix Cobalt Blue, Crimson Alizarin, Yellow Ochre and Titanium White and, using the same brush, paint in the cliff side, starting on the left and making the colour lighter as you work to the right.

Stage 3
With the same brush and colours, start at the left of the cliffs and paint in the line of large rocks. When you reach the cliff face, work your paint a little lighter in tone (add more Titanium White). This will help the cliff that comes in front to stand away from it. Now with darker paint, paint in that cliff – work your brush strokes down from the top so that any marks left by the brush will give the impression of rocks or cliffs. As on the row of large rocks, work the paint lighter in tone behind the jetty wall. Again, this will help to separate the two planes. Make the colour darker still (use much less Titanium White) and paint in the jetty wall, the large dark rock left of centre, and the slipway behind the jetty. As you paint the rocks and cliffs, drag your paint down and over the drawn line where they meet the sea. This will allow for the sea to be painted back over the bottom of the cliffs.

Finally, with a mix of Titanium White, Cobalt Blue, Yellow Ochre and a little Crimson Alizarin, paint over your under-painting of the wave shadows.

(left, top to bottom) **figs. 178, 179 and 180** Stages 1, 2 and 3

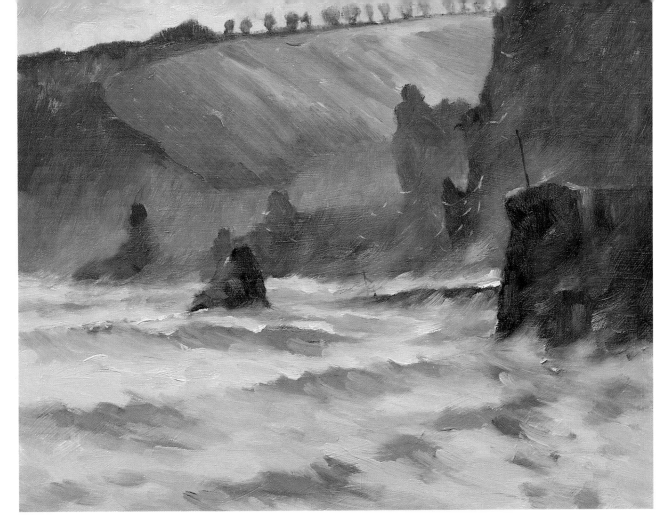

Fig. 181 Finished stage. Primed hardboard, 25 × 30 cm (10 × 12 in)

Finished stage

Paint in the sea, using your No. 4 and No. 6 brushes. Mix Titanium White, Cobalt Blue, Crimson Alizarin and Yellow Ochre for this. For the areas where the sea is sunlit, add Cadmium Yellow to Titanium White. Work your lighter colours into the darker tones, which will make the water look more fluid. This is like painting clouds; you are painting wet into wet – enjoy it! When you have done the sea, using your No. 4 brush almost dry, drag into and over the existing 'sea'

paint. Work it **very** delicately over the waves and up over the base of the rocks and cliffs (see **fig. 183**). This gives the illusion of spray and, of course, atmosphere.

Use your 'sea' colour and your No. 2 brush to paint in the sky. Finally, put one or two highlights on the waves. I have put in only two or three; if I had painted a lot, the effect would have been lost. Finally, suggest the seagulls with your rigger brush. You need only a few brush strokes but they introduce life into the painting, so they are important.

Fig. 182 Detail from the finished stage, **fig. 181**

Fig. 183 Drag the brush delicately over the waves to suggest spray

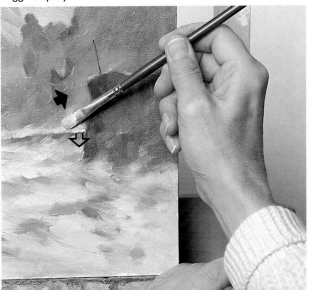

HALF-HOUR EXERCISE

Fig. 184 Stage 1

Fig. 185 (above) Stage 2

Fig. 186 (below) Stage 3

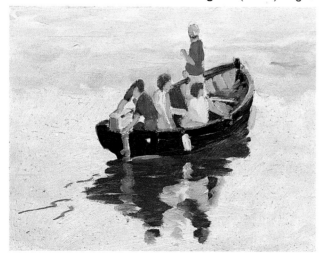

Because half-hour exercises are so valuable, I decided to use one for this demonstration. Unfortunately, I wasn't able to work outdoors because, as in all the demonstration exercises, the painting had to be photographed at each stage. I made a pencil sketch of the boat and also took a photograph to use as reference to work from. Try this exercise and others in the book before you go outside to work from life; they will give you confidence.

When I work in oil I always allow an extra ten or fifteen minutes on top of the half hour for mixing colours and cleaning the palette and brushes during painting. It isn't a case of popping the brush in water and giving it a quick rinse, as in watercolour painting. Not counting the photographic time in between each stage, this exercise took me 38 minutes without the drawing. See what you can do. Remember, speed is not important; it's what you achieve by **doing** paintings in half hour (see Lesson 15, page 66).

I worked on primed hardboard painted over with a Cobalt Blue and Crimson Alizarin turpsy wash.

Stage 1
Draw in with an HB pencil first; this gives you a more accurate drawing. Then paint over, using your No. 2 brush with a turpsy wash of Cobalt Blue and Crimson Alizarin, filling in the tonal areas.

Stage 2
Now paint in the flesh colour with your No. 2 brush and a mix of Cadmium Red, Cadmium Yellow and Titanium White, then the dark and light colours for the clothes and hair.

At this point, let me say that if you were doing this exercise outdoors, painting the boat as those on board tried to start the engine, the most important part of the painting would be the drawing. After this was established, the boat and people in it could move or assume different attitudes, but within reason their colours would remain the same; therefore you could relax a little while painting because the main problem of movement – the fact that the boat might move away – had been almost resolved with the drawing.

Now paint in the boat.

Stage 3
Paint in the reflection of the boat and people with your No. 2 brush – you will have your colours mixed from the previous stage so this will not take long. With a mix of Titanium White, Cobalt Blue, Crimson Alizarin

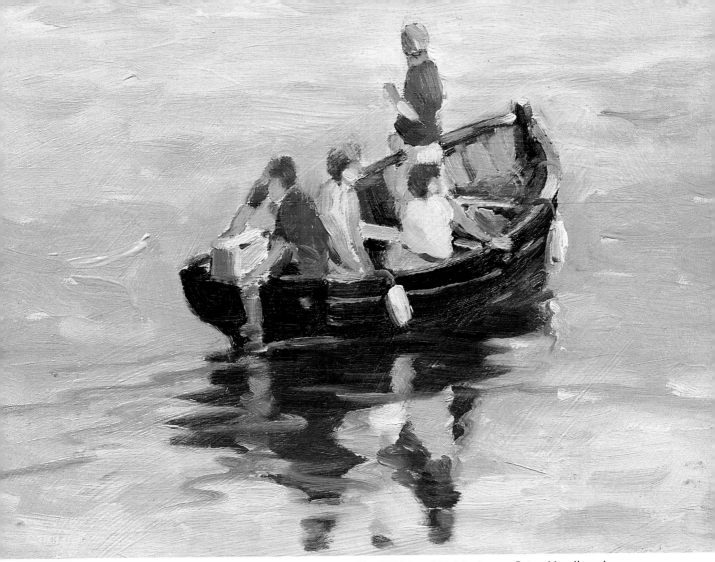

Fig. 187 (above) Finished stage. Primed hardboard, (reproduced actual size)

Fig. 188 (below) Work the paint for the light coloured water into and over the reflection to help give movement

and a little Yellow Ochre, and your No. 4 brush, start painting in the sea from the top downwards, changing the colours and blending them together as you work down the painting.

Finished stage

Continue to paint the water down the board. Work the light-coloured water into and over the reflection with your No. 2 brush (see **fig. 188**) to help give movement to the water. Finally, put a highlight on the fenders and top of the outboard motor.

When you paint a subject such as this from references, not real life, you will find that the finish is more controlled; if you were working from life, there would be much more freedom of brush-stroke simply because you were painting a moving object. Even if it stayed there for an hour, you would be working quickly, assuming – quite rightly – that your subject might move away any minute. But this freedom creates a tremendous feeling of life in your painting.

Don't be afraid to try a half-hour painting next time you are outdoors; you will probably be surprised at your results.

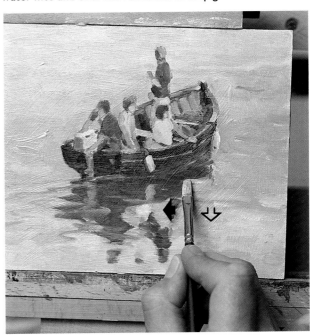

FLOWERS

Flowers, I must admit, are not my favourite subject to paint, perhaps because I am not a keen gardener, although I love gardens. But once I become involved with them I enjoy the subject as much as any other. Anyway, my editor loves paintings of flowers, so our last lesson is a display of chrysanthemums, which I painted on canvas on a white background.

Stage 1

Draw in with a HB pencil first, then paint over with a turpsy mix of Cobalt Blue and Crimson Alizarin, using your No. 1 brush, and your pencil drawing as a guide. Fill in the dark areas with the same mix. The flower at the top centre, where I haven't drawn in the petals like all the other flowers, was a different kind of chrysanthemum; it looked like a screwed-up piece of tissue paper. I decided it would always be a problem to give it definition, so I painted it the same as all the others. I painted these from life, and when I bought them the odd one must have crept in without my noticing it.

When you are painting flowers be prepared for them to move during the painting session, or for buds to open, especially overnight. If this happens, you may be at a stage where it doesn't affect your painting; if it does, leave your painting as it is and use the other flowers as a guide (colour, shape, tone etc.) for the rest of the painting.

Stage 2

Start by mixing Cobalt Blue, Cadmium Yellow, a touch of Crimson Alizarin and Titanium White, and with your No. 4 brush paint in the dark leaves, starting from the centre. With the same brush and a mix of Titanium White, Yellow Ochre and a touch of Crimson Alizarin and Cobalt Blue, paint in the background to the flowers. Start at the top and work down, making the paint darker (less Titanium White and a little more Cobalt Blue) as you work down the left-hand side of the flowers. When you paint up to the flowers don't worry about being precise; if you go over your drawing this can be rectified later.

Now make a thin (turpsy) colour from Cadmium Yellow, Crimson Alizarin and Cobalt Blue, and paint in the table with your No. 6 brush. Do this freely, working from left to right, and it will help to give a suggestion of grain to the table top.

Next, with a turpsy mix of Cobalt Blue, Crimson Alizarin and Yellow Ochre, paint in the reflection of the teapot. This time, work your brush strokes downwards, starting at the teapot and working down, out of the picture.

Fig. 189 Detail from the finished stage, **fig. 194**, page 119

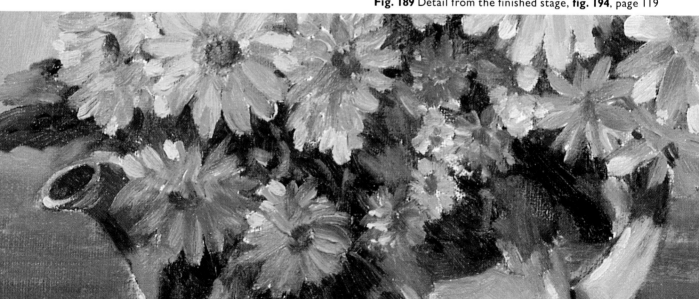

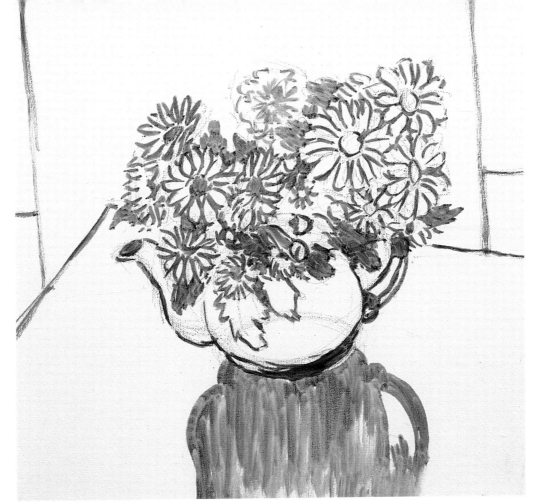

Fig. 190 (above) Stage 1
Fig. 191 (below) Stage 2

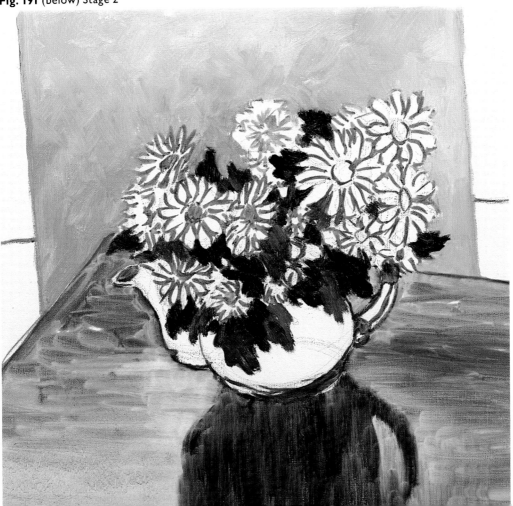

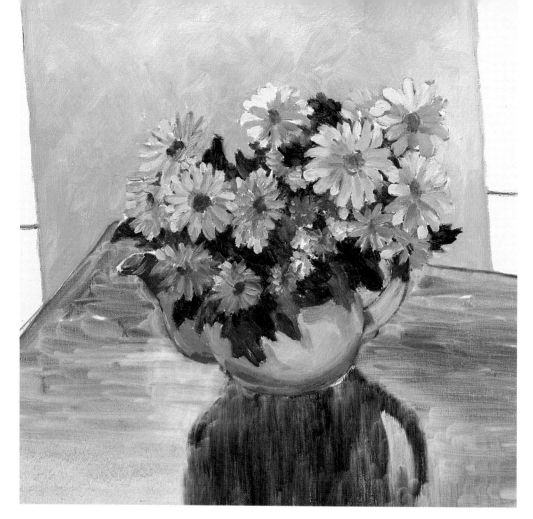

Fig. 192 (above) Stage 3

Fig. 193 (below) Paint in the sunlit petals with your No. 2 brush

Stage 3

Using your No. 4 brush, paint in the teapot with a mix of Titanium White, Cobalt Blue, Crimson Alizarin and a touch of Yellow Ochre. Keep the teapot dark in key, but make it lighter as you approach the middle of the pot. Also, put the dark brown line on the teapot spout, handle, and where it shows underneath the flowers to the top right of the teapot.

Now to the exciting part, the flowers. Start with the yellow ones. Mix Cadmium Yellow, a little Crimson Alizarin, Cobalt Blue and Titanium White, and paint them with your No. 2 brush. Then paint in the light part of the petals; where the light is catching them, mix Cadmium Yellow with Titanium White and just a touch of Crimson Alizarin. When you have done this, if you think it necessary, you can use your No. 6 sable brush to paint some of the petals more carefully.

In exactly the same way, paint the pink flowers, putting in the dark shadow areas first, with a mix of Titanium White, Crimson Alizarin, Cobalt Blue and a little touch of Cadmium Yellow. Then put in the centres, using a mixture of Cadmium Yellow, Cobalt Blue, a touch of Crimson Alizarin and a touch of Titanium White. With your No. 2 brush paint in the sunlit areas of the petals, using the petal colours but with more Titanium White added (see **fig. 193**).

Finished stage

Start by preparing a thin mixture of Titanium White, Cobalt Blue, and a touch of Cadmium Yellow, and paint in the two side panels at the back of the table. Although there were two panels at each side of my flowers, at this stage I decided to paint only one of each. Two would have looked too fussy.

The top of the table is next. Mix Cadmium Yellow, Crimson Alizarin, Cobalt Blue, and a little Titanium

Fig. 194 Finished stage. Canvas, 30 × 30 cm (12 × 12 in)

White, and work over your under-painting. Make the table edge more horizontal than I have done – it slopes down to the right too much on my painting! Add more yellow colour to the left of the reflection and add a bluish-white to the right; mix Titanium White, Cobalt Blue and Crimson Alizarin, then blend this with the table colours on the painting. At this stage paint up to but not over the reflection.

With your No. 6 sable brush paint a yellowish-white highlight on the teapot spout, handle, and front. Now drag your No. 4 brush very delicately over the table paint on to the reflection, to merge it into the table

(wet-on-wet technique). Now add some reflections from the flowers on this. Put a highlight on to the reflection of the teapot handle. Paint some light green on the leaves where the light hits them. Finally, look at your painting and put highlights and dark tones where you feel they are needed.

When you are copying my exercises, if you feel your way of working, which is natural to you, wants to come out, then do let it. This is what I want you to find, your own natural style. It will happen. But above all, you must enjoy painting; I know you will.

I hope you have enjoyed the course.

Part Seven
GALLERY

The blue boat (detail). Canvas, 61 × 91 cm (24 × 36 in) (opposite); *The old barge*. Primed hardboard, 30 × 41 cm (12 × 16 in) (above); *Harpford, Devon*. Primed hardboard, 25 × 30 cm (10 × 12 in) (below)

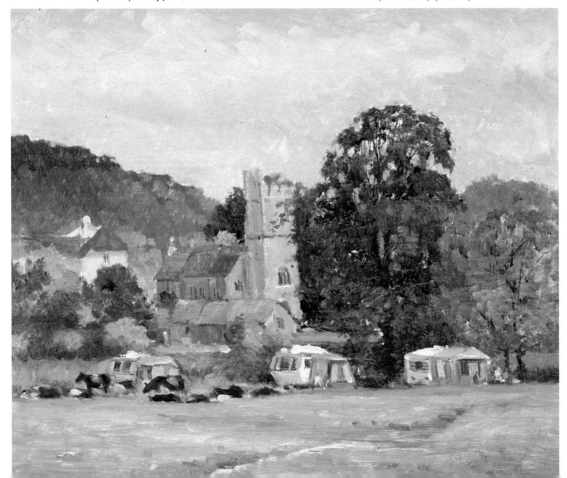

Brixham Harbour, Devon.
Canvas, 76 × 102 cm (30 × 40 in)

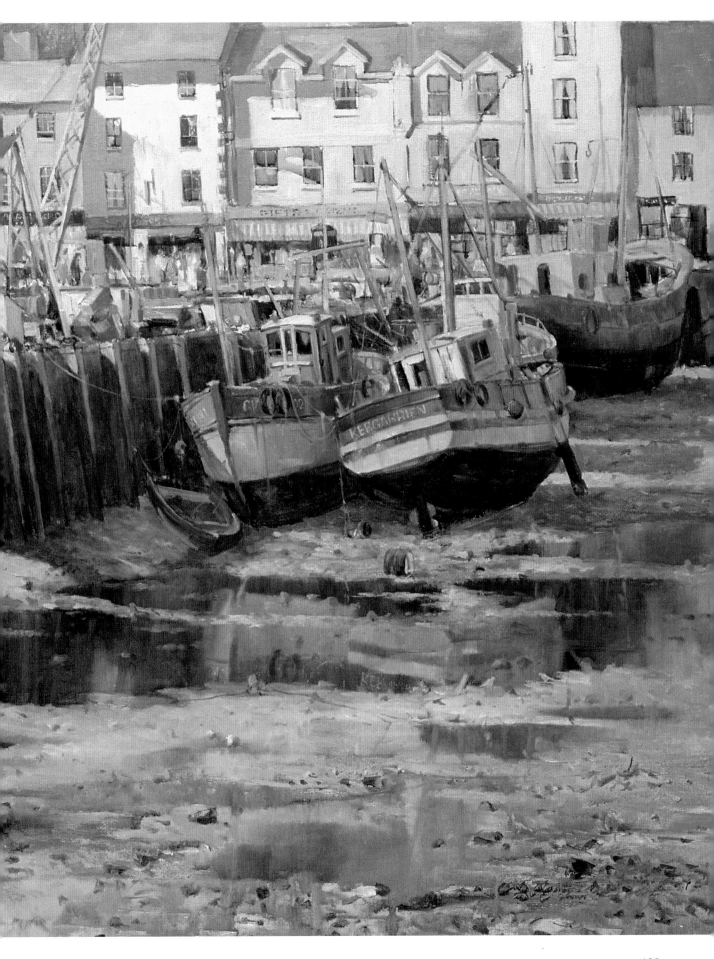

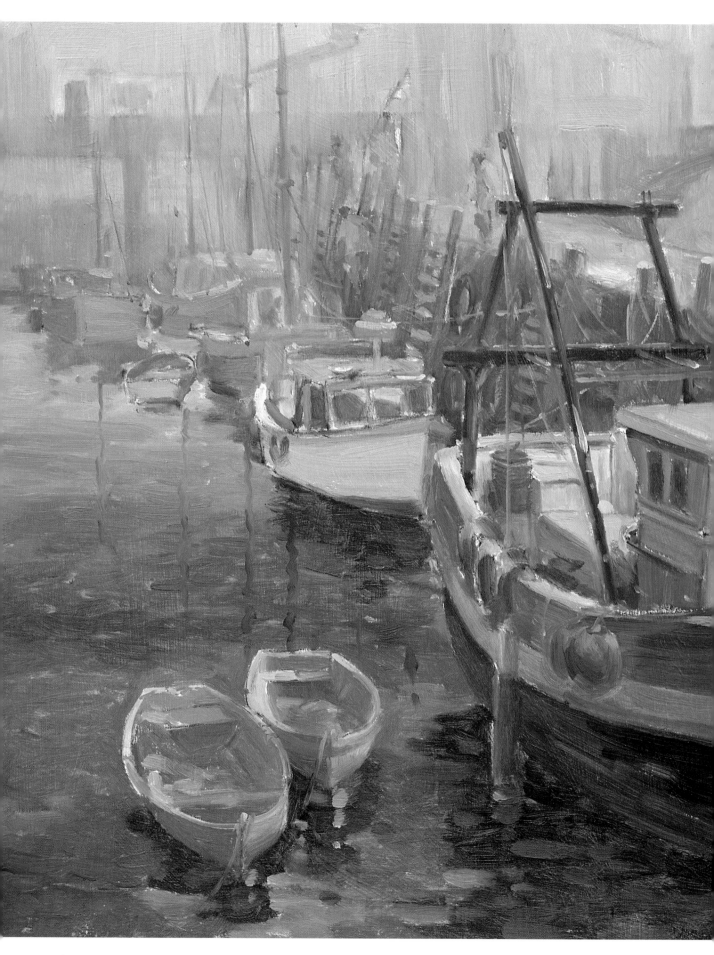

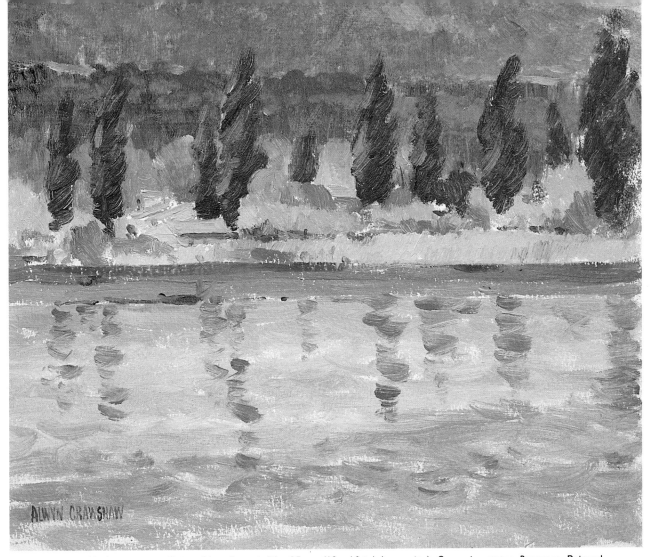

Polperro Harbour in mist. Primed hardboard, 30 × 25 cm (12 × 10 in) (opposite); *Oncoming storm, Provence.* Primed Whatman paper, 25 × 30 cm (10 × 12 in) (above); *Low tide.* Primed Whatman paper, 25 × 30 cm (10 × 12 in) (below)

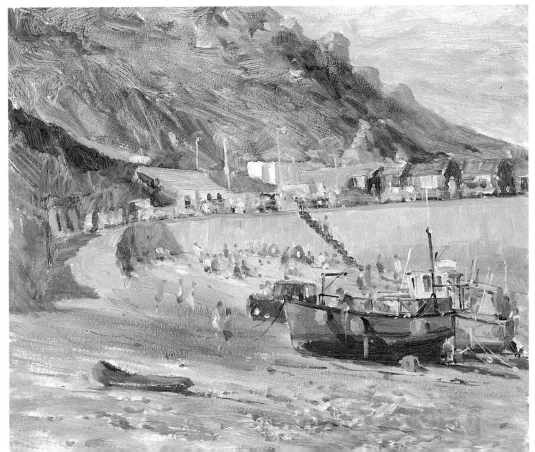

125

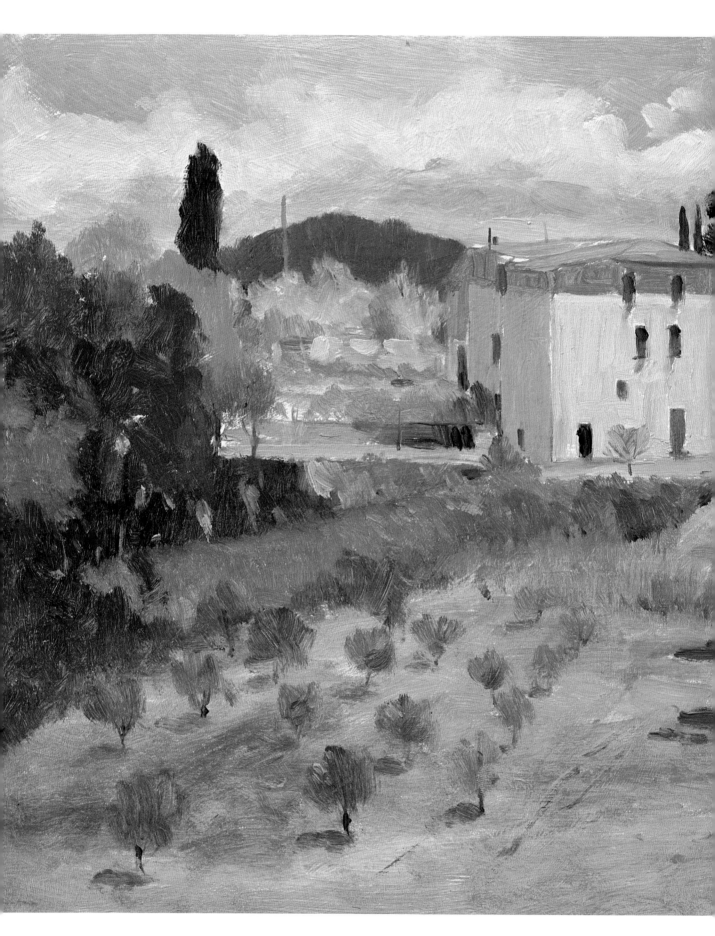

INDEX

Page numbers in **bold** type refer to photographs and illustrations

A Tuscan farm. Primed hardboard, 25 × 30 cm (10 × 12 in)